IMAGES
of America

SMITHVILLE

BLIND MACHINE.
For Cutting the Mortices to Receive the Slats.

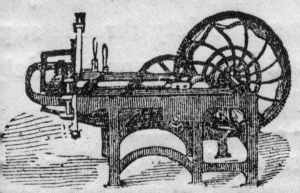

This machine is somewhat complicated, and requires a good mechanic to keep it in order to do good work.

It is capable of doing great amount of work and can be operated by boy when put in order. It is self-operating, and stops its own motion when its work is done. It cuts and clears its mortices at the rate of 40 per minute, spaces accurately and gives any angle to mortice required.

Weight,..150 lbs
Price,..$100

This advertisement was placed in the October 30, 1873, *New Jersey Mechanic* newspaper for a "Blind Machine for Cutting the Mortices to Receive the Slats" in window blinds. This was Hezekiah Bradley Smith's first patented woodworking machine, patented April 17, 1849, patent No. 6,343. It was the beginning of Smith's use of all-iron machines. Their sturdiness propelled him to the forefront of the woodworking industry. (Courtesy of the Burlington County Board of Chosen Freeholders/Division of Parks.)

ON THE COVER: Riders on the Mount Holly and Smithville Bicycle Railroad cross the North Branch of the Rancocas Creek in the mid-1890s. Single and tandem vehicles are shown on the dual track that traveled between Mount Holly and Smithville, New Jersey. Inventor Arthur Hotchkiss brought his bicycle railroad idea to the H.B. Smith Machine Company in Smithville in 1891. Together, they formed a new company to build the railroad so workers could commute from Mount Holly to the Smithville factory. It was also to be used as an exhibition site for future buyers of the railroad. (Courtesy of Kim and Wayne Batten.)

IMAGES of America
SMITHVILLE

Dennis McDonald
Foreword by Barbara Solem

Copyright © 2019 by Dennis McDonald
ISBN 978-1-4671-0356-5

Published by Arcadia Publishing
Charleston, South Carolina

Printed in the United States of America

Library of Congress Control Number: 2019939523

For all general information, please contact Arcadia Publishing:
Telephone 843-853-2070
Fax 843-853-0044
E-mail sales@arcadiapublishing.com
For customer service and orders:
Toll-Free 1-888-313-2665

Visit us on the Internet at www.arcadiapublishing.com

All the work producing this book could not have been accomplished without the full support and love of my wife, Rose Shields. Thank you.

Contents

Foreword 6

Acknowledgments 7

Introduction 8

1. Hezekiah Bradley and Agnes Smith 11
2. Smithville Village 33
3. H.B. Smith Machine Company 73
4. The American Star Bicycle 89
5. The Mount Holly and Smithville Bicycle Railroad 111

Foreword

It is hard not to be captivated by Smithville Village. There's the beauty of its stately mansion, surrounded by a natural and lovely landscape on the banks of the Rancocas Creek. But maybe most appealing is its rich and bountiful history, with characters so colorful that even Charles Dickens couldn't have made them up. So how could Dennis McDonald, after many years of visiting the site, resist searching out more of Smithville's bygone years and then finding a way to share it with all of us?

That curiosity to learn more about the history and the people that make up the southern part of the state where Dennis grew up possibly started soon after his first summer job picking blueberries in Pemberton when he was just 14. Growing up in Cherry Hill, Dennis knew there was more to South Jersey than what surrounded him. And soon after becoming mobile, he and his brother began exploring many of the backroads within an afternoon's drive of their home.

And it wasn't long before Dennis began capturing the images that captivated his imagination on those road trips. Nor is it surprising that photojournalism would one day become his career. During the 38 years Dennis worked for the *Burlington County Times*, he had many opportunities to travel those same back roads of his youth, photographing and documenting the landscape and its people while learning more of its rich history. Perhaps it is his sense of place that drives Dennis to learn all he can about his beloved South Jersey, the region that he has made his home. In keeping with this lifelong interest, just prior to retirement, Dennis authored a well-researched photographic history of the town where he now lives, Medford, New Jersey.

But with more time on his hands he began researching Smithville, whose beauty and history had always interested him. The final product is a rich photographic journey through the history of a fascinating place, beautifully captured by Dennis McDonald, a meticulous researcher who knows a good story when he sees it!

—Barbara Solem
Author of
Ghost Towns: And Other Quirky Places in the New Jersey Pine Barrens
Batsto Village: Jewel of the Pines
The Forks: A Brief History of the Area

Acknowledgments

Three years ago, I began digitizing the Burlington County Parks Department collection of Smithville photographs under the direction of superintendent John Smith. His enthusiasm for the project was encouraging and continuous. Curious county historians Marisa Bozarth and Eric Orange also provided valuable guidance during this process. Special thanks go to the Burlington County Board of Chosen Freeholders, who decided many years ago to preserve Smithville as the first county park.

Huge thanks are extended to William C. Bolger, who wrote *Smithville: The Result of Enterprise*. His history of all things Smithville was invaluable. Thanks go to Sherry Brandt and Lawrence Gladfelter with the Friends of the Mansion at Smithville, a group devoted to keeping Smithville's history alive every day; and to Stockton University professor Thomas Kinsella, PhD, director of the South Jersey Culture and History Center, who published my article "The Future of Transportation: The Bicycle Railway" in the Spring 2016 issue of the journal *SoJourn*.

A book of photographs depends on many sources for the images. I would like to thank Richard Mahn, Kim and Wayne Batten, James Denworth, Sandy Morrone, Barb and Ev Turner, Sheila D'Avino, Leonard Carey Williams, Lorne Shields, Paul W. Schopp (South Jersey Cultural and History Center), Kelly Dyson and Georgia Zola (Library of Congress), Susannah Carroll (Franklin Institute), Derek Grey and Lauren Algee (District of Columbia Public Library), Christine Lutz (Rutgers University Libraries), Sarah Weatherwax (Library Company of Philadelphia), Jane Gastineau (Allen County Public Library), the Burlington County Historical Society, Denise Saia (Hammonton Historical Society), Bette Epstein (New Jersey State Archives), Larry Tiger (Mount Holly Historical Society), Michael Lewis (Williams College), and the late Joe Laufer, director of the Smithville Conservancy for his friendship.

Thanks go to Pine Barrens author Barbara Solem for writing the foreword, editor Eric Gardner for making my words coherent, and Erin Vosgien and Stacia Bannerman at Arcadia Publishing for seeing this book through to the end.

INTRODUCTION

In the early 1830s, Jonathan Lippincott Shreve and Samuel Shreve purchased the Parker Mills property, the site of a sawmill and gristmill, on the North Branch of Rancocas Creek in Burlington County. There, the brothers built a calico printing works and spinning and weaving mills. They began manufacturing cotton thread, employing Samuel Semple, a master weaver from Scotland, who oversaw the operation. At that point, the growing mills employed over 200 workers and housed 420 people. The cotton mill village, ultimately named Shreveville, included brick houses for the workers, a gristmill, a store, a school, and a Greek Revival mansion built about 1840.

Unfortunately, as the Shreves were expanding their mills, the cotton textile industry in the United States was declining due to overproduction. By the 1850s, the brothers were mortgaging their property and relying on loans from another brother to survive. By April 1855, the company was out of business. The two brothers died shortly thereafter.

Ten years later, inventor/industrialist and Vermont native Hezekiah Bradley Smith purchased the factory, village, and mansion, 45 acres in all, for $20,000. An abandoned factory town along the North Branch of Rancocas Creek seemed an ideal place to expand his iron woodworking manufacturing plant (then based in Lowell, Massachusetts). This was especially true since a recently completed railroad line ran through the village, placing the markets of Philadelphia and New York within easy reach.

There was a problem, however. Smith, who presented himself in New Jersey as married to Agnes, was still married to his first wife, Eveline, who was in Vermont with three of their children. While in Lowell, Smith had paid for the former mill girl Agnes to attend Penn Medical University; she graduated in 1861 as a doctor of medicine, majoring in chemistry. Moving to New Jersey offered a fresh start to both of them. Thus Smith moved his business and his new wife, Agnes (Gilkerson) Smith, to the town that would soon bear his name.

Many of the employees from Lowell moved to the new location and lived in the mansion while the mill complex was converted to a woodworking manufacturing facility. Change came to the village too. The single-family housing was updated, construction began on a new schoolhouse, a dormitory for single men and apprentices was built, and a farm complex was added so fresh vegetables and dairy products could be made available for purchase by the factory workers and their families.

Agnes had a hand in many of the ideas for the village and took over editing the company trade journal, the *New Jersey Mechanic*. She transformed it from a strictly industrial newspaper to a publication that offered information on world events, literature, and woodworking news. She also used her medical degree to create various products for women, including Madam Smith's Celebrated Hair Restorer and Beautifier.

Business was booming for H.B. Smith, Agnes, and the machine company in the 1870s. Prior to arriving in Burlington County, Smith held nine patents for his all-iron woodworking machines. He increased his share of the market by inventing new machines for mortising, tenoning, sawing,

and planing. He exhibited his machinery at numerous fairs and at the Centennial Exhibition held in Philadelphia, Pennsylvania, in 1876. He hired creative executives who brought new ideas and patents to the company. They included Joseph J. White, William S. Kelley, John Salter Jr., and James Perry. The H.B. Smith Machine Company was incorporated in 1878.

The village of Smithville was also undergoing a renaissance. A gazebo was built in the park between the duplex houses and Rancocas Creek for concerts. Smith organized a brass marching band, hired a professional bandmaster, and purchased tailor-made uniforms for them. He also hired a full-time violinist named Prof. John J. Pieterse. An opera house was added onto the Mechanics House to provide a place for winter concerts, lectures, and other entertainments for the workers and their families.

The Smiths were also adding their own touches to the former Shreve family mansion and the walled grounds surrounding it. In 1874, Fritzy Gsell, a gardener from Alsace, France, was hired to plan and tend to the grounds around the mansion. A cast-iron grape arbor was built at the factory and installed in the front and rear of the mansion. Symmetrical walkways with boxwood borders were built in front of the mansion. Fountains, sculptures, and flowerpots were all part of the formal garden put in place by the gardener. Later, a conservatory was built containing rare and exotic plants. Smith then began to acquire a menagerie in his backyard. He acquired deer, elk, caribou, and, lastly, a moose. The moose, named February, was harnessed and trained by a staff member to pull a cart.

In the farm complex across the street from the mansion, Smith built a brick and iron dairy barn, worker's houses, and a 120-foot observation tower. The tower contained 150 cast-iron, spiral steps leading to a platform where all the land owned by Smith could be seen.

In November 1878, H.B. Smith was elected to serve in Congress from the Second District of New Jersey, beating incumbent J. Howard Pugh. On the day after the election, news of his marriage to his first wife was printed in many major newspapers. The *New York Times* article featured the headline "Hezekiah's Two Wives—A Congressman's Predicament. One Wife in Vermont and Another in New Jersey—The Greenback Congressman-Elect in Trouble." Smith denied it all in a speech to his employees and in a press release sent to newspapers. Two years later, he lost his reelection bid.

The 1880s brought change to the community of Smithville. George Washington Pressey, an inventor from Hammonton, New Jersey, came to the Smith Machine Company inquiring whether it would manufacture a new bicycle. Pressey had redesigned the high-wheel bicycle by placing the small wheel in the front and making it the steering wheel, providing more stability. He also used a treadle drive to propel the bicycle instead of a crank mechanism to avoid patents owned by the Pope Manufacturing Company, the largest maker and importer of high-wheel bicycles in America. Smith signed an agreement with Pressey in 1881 to build the American Star bicycle, and the H.B. Smith Machine Company expanded into a field that was unknown to it before—and into what was becoming a national fad.

On January 26, 1881, Agnes Gilkerson Smith died of cancer, and Hezekiah's world turned upside-down. Agnes and Hezekiah had talked about changing his will and leaving his estate to establish a training school for young mechanics. The will and the school would be overseen by the directors of the H.B. Smith Machine Company.

Smith became very busy in the years after Agnes's death. In 1882, he ran for office again and won a seat as a New Jersey state senator. He expanded the mansion complex with a billiard room, dining room, cardroom, and bowling alley—with many of the items made at the company machine shop. Smith used this new entertainment annex as a political meeting and gathering spot. He went on numerous hunting trips with his friends and acquired more animals for his estate's menagerie. He kept up with his company team of bicycle racers, who were competing up and down the East Coast. He oversaw the building of new houses in the lower village with lumber he had bought while traveling in Michigan. He oversaw the development of a steam-powered tricycle. Smith seemed to be everywhere doing everything, but on October 28, 1878, he was taken ill at home and died soon after on November 3.

Less than two months after Smith's death, his will was contested by his first wife, Eveline Verona Smith, and her children, especially 39-year-old Elton Smith. The trial to settle who would control H.B. Smith's fortune continued for years. During this time, the H.B. Smith Machine Company continued prospering under the direction of newly named president William Kelley and other longtime Smith executives.

In 1891, Arthur Hotchkiss approached the company executives about a wild idea. Hotchkiss wanted the Smith Machine Company to construct a bicycle railroad from Smithville to Mount Holly. A bicycle-like vehicle would ride atop a fence-like structure and be human powered. He hoped the company would allow this railroad to be used as a sales promotion for a new wave of transportation. The company agreed. It built a 200-foot test track outside the factory, formed a new corporation, sold shares, and surveyed a straight-line route between Mount Holly and Smithville along and across Rancocas Creek. The 1.8-mile route was built and opened to the public during the Mount Holly Fair on September 13, 1892. The railroad was an initial success, with 5,000 riders in the first week. Hotchkiss was happy with the favorable results and in November announced his intentions to take the bicycle railroad to the World's Columbian Exhibition in 1893. At the Chicago fair, the H.B. Smith Machine Company exhibited its woodworking machines and the American Star bicycle, while Hotchkiss demonstrated his bicycle railroad with vehicles built by the Smith Machine Company. Unfortunately, no one saw the bicycle railroad as a real form of transportation. The only licenses sold were to amusement park operators as part of their entertainment complexes. George Bean of England bought the rights to the bicycle railroad and built numerous rides in his country. The bicycle railroad amusement ride lasted longer than the original line built between Mount Holly and Smithville; the Smithville railroad operation ceased in 1898, while some of the amusement rides lasted until 1906.

On March 2, 1897, the courts finally decided in favor of Smith's first wife's family, and Elton Smith took over his father's estate. By 1900, his family was residing in the mansion at Smithville. He ran the company with great success until his death in 1917. Elton's family remained at the estate but was not skilled in business. The company and village went into decline and became shadows of their former selves. Sales of various belt sanders kept the company alive, but the worker's village deteriorated. The Mechanics House was torn down in 1948, and the brick worker's houses were demolished soon after. Train service to Smithville ended in the early 1950s, and the mansion was sold to a non–Smith family member in 1961. In 1975, the Burlington County Board of Freeholders bought the village, the mansion, and what was left of the factory for development into the first county park.

When Hezekiah B. Smith arrived in Shreveville in 1865, he brought revitalization to the area around Mount Holly. Smith and his company executives held more than 50 patents. At the height of production, the H.B. Smith Machine Company employed 300 people and produced 150 woodworking machines, one quarter of all woodworking machines in the nation. He left quite a legacy.

One
Hezekiah Bradley and Agnes Smith

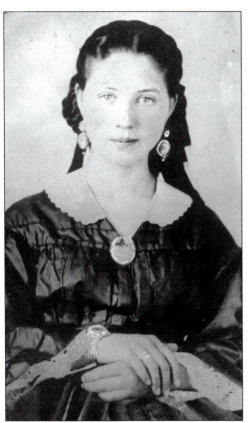 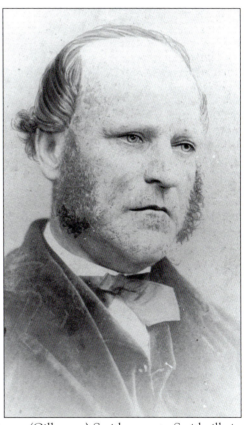

Inventor Hezekiah Bradley Smith and his wife Agnes (Gilkerson) Smith came to Smithville in October 1865. Both born in Vermont, they met in Lowell, Massachusetts, where Agnes worked in the mills and Smith operated a woodworking plant. Agnes, 21 years younger than Hezekiah, left her job at one of the textile mills and went to work for him as a clerk or secretary. Hezekiah made sure that Agnes finished high school and then paid for her to attend medical school in Philadelphia before their move to New Jersey. (Both, courtesy of the Burlington County Board of Chosen Freeholders/Division of Parks.)

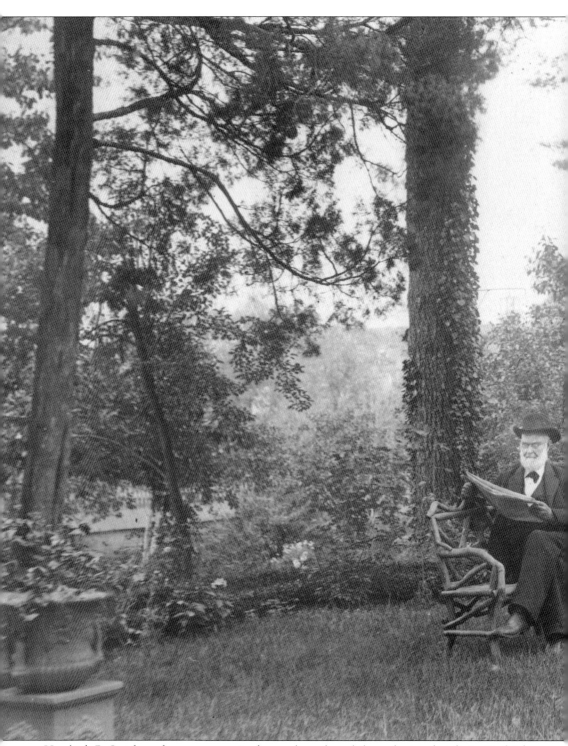

Hezekiah B. Smith reads a newspaper in the south garden while professional violinist Prof. John J. Pieterse plays in the background. Smith enjoyed playing the violin and hired Pieterse as a full-time resident violinist on the household payroll. Hezekiah surrounded himself and Agnes with

an idyllic environment that included formal gardens, statuary, fountains, a greenhouse, fruit tree groves, and a grape arbor outside their mansion. (Courtesy of the Burlington County Board of Chosen Freeholders/Division of Parks.)

12			Rainer Charles	26	M	W	Laborer	1200	100	" "
13			— Joanna	30	F	W	Domestic Servant		✓	Ireland
14			Queen Thessana	30	F	W	" "		✓	New York
15	194	198	Willitts Aaron	37	M	W	Laborer		500	New Jersey
16			— Martha A.	39	F	W	Keeping House			" "
17			— Josephine	12	F	W	At Home			" "
18			— Corrinda	10	F	W	" "			" "
19			— Laura	6	F	W				" "
20			Stafford Edward	27	M	W	Machinest		✓	" "
21			Carr Adam	18	M	W	A. To Moulder In Iron Foundry		✓	New York
22			Lippincott Henry	19	M	W	Apprentice to Machinest		✓	New Jersey
23			Grant Edward	19	M	W	"	"	✓	" "
24			Doan Eugene	16	M	W	"	"		" "
25	195	199	Leonard A. J.	44	M	W	Blacksmith	800	100	Vermont
26			— Roeanna	38	F	W	Keeping House			"
27			— Sumner	14	M	W	Attending School		✓	"
28	196	200	Smith Hezekiah B	53	M	W	Manufactory of Morses Working Machines	100.000	100.000	"
29			— Agnes M	32	F	W	Keeping House			"
30			Toby Emma	16	F	W	Domestic Servant		✓	New Jersey
31			Farley Mary	34	F	W	" "		✓	Ireland
32			Cream Ella	20	F	W	" "		✓	New Jersey
33			Cobb Hosea	53	M	W	Farmer		✓	Vermont
34			Clark Nathan	45	M	W	Farm Laborer		✓	"
35			Bryant O. A	61	M	W	Book Keeper		✓	"
36			Smith Walter	20	M	W	Clerk		✓	New Jersey
37			Rainman Elwyn	28	M	W	Watchman		✓	Vermont
38			Southgate B. F.	66	M	W	Machinest		✓	"
39	197	201	Jones Primor	46	M	B	Laborer		✓	Maryland
40			— Catharine	41	F	B	Keeping House		✓	Delaware

The 1870 census of Burlington County shows Hezekiah Bradley Smith with a property value of $100,000 and his personal estate also worth $100,000. In 2019 dollars, that would be almost $4 million. By comparison, workers at Smithville rarely owned their home and their total worth was negligible. For example, Charles Rainer, a laborer, had a total worth of $1,300, and A.J. Leonard, a blacksmith, had a total worth of $900. In 2019 dollars, Rainer's worth would be $37,600 and Leonard's would be $25,600. (Courtesy of the Burlington County Board of Chosen Freeholders/Division of Parks.)

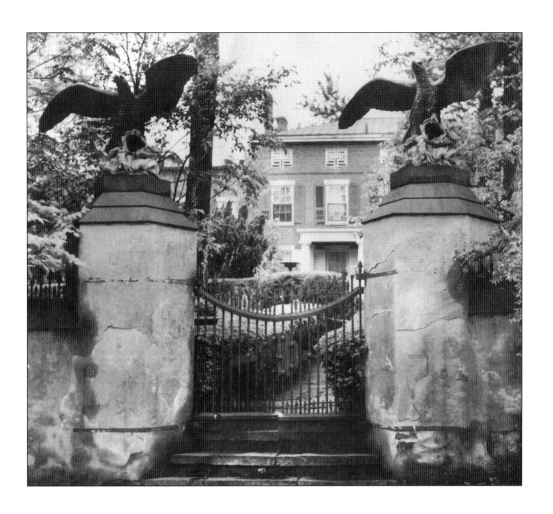

The front of the Greek Revival mansion where Hezekiah and Agnes lived when they moved to Smithville in 1865 is pictured here. The home was built in 1848 by the Shreve brothers when they operated a cotton mill on the adjacent property. Agnes Smith oversaw a household of cooks, maids, and housekeepers. In March 1874, she placed the advertisement below in the *New Jersey Mechanic* trade journal looking for additional staff. (Both, courtesy of the Burlington County Board of Chosen Freeholders/Division of Parks.)

WANTED.

A good Cook, Washer and Ironer; high wages paid. The best reference required.
Address, MRS. A. M. SMITH,
 Smithville, Bur. Co., N. J.

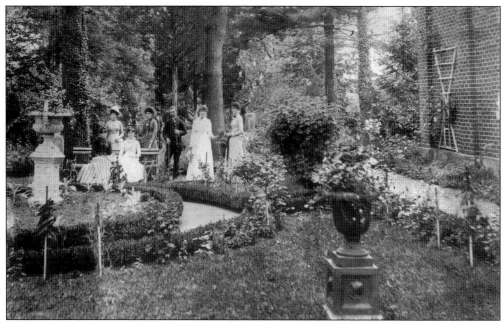

Prof. John J. Pieterse, resident violinist, stands with a group of visitors in the east garden of the mansion in 1886. Most of the flower urns, fountains, statuary, and boxwood pathways remain to this day. (Courtesy of the Burlington County Board of Chosen Freeholders/Division of Parks.)

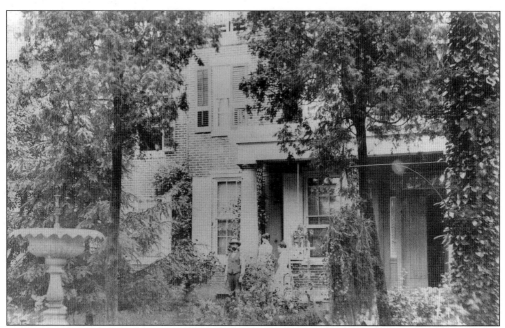

Gardener Fritzy Gsell, hired in 1874 from Alsace, France, stands with two visitors near the north entrance of the mansion. Fountains and lush gardens surround the walled mansion on all sides. The appearance of the property was very important to the Smiths, who often entertained friends, politicians, and business contacts. (Courtesy of the Burlington County Board of Chosen Freeholders/Division of Parks.)

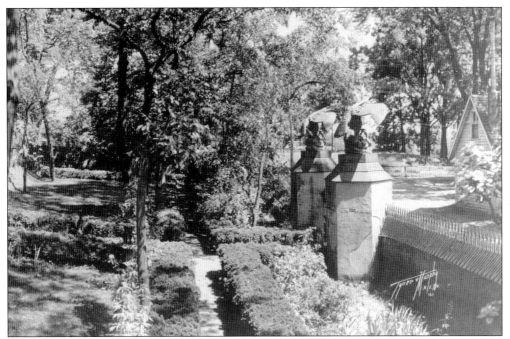

This view of the front of the Smith home shows iron eagles placed on pillars on both sides of the gated entranceway. Boxwood pathways lead to the front door and along the perimeter of the walled property. An iron arrow–topped brick wall surrounds the entire mansion property. (Courtesy of the Burlington County Board of Chosen Freeholders/Division of Parks.)

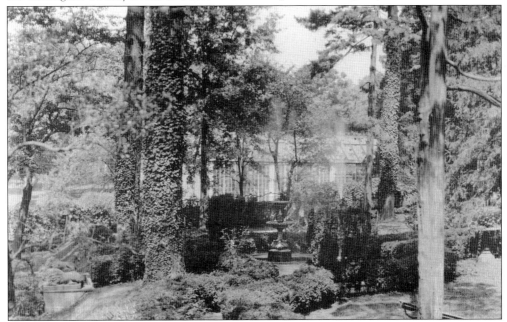

The south (front) formal garden with lion statues, seen at lower left, and one of the many fountains are the first things seen upon entering the mansion property. In the background is the glass conservatory built in 1883. The boxwood-lined pathway leads between the lions to the front entrance. (Courtesy of the Burlington County Board of Chosen Freeholders/Division of Parks.)

This overall view of the north gardens at the rear of the mansion shows the tennis court at lower left, the grape arbor, the carriageway, and the annex buildings. The second floor of the annex was built after Agnes died. It included a billiard room, a cardroom, and a bowling alley. Below is the former schoolhouse, located in the northeast corner of the grounds. It replaced a smaller school and was used not only by the worker's children but also children from surrounding farms. The building was also used after hours as a lyceum by members of the village. (Both, courtesy of the Burlington County Board of Chosen Freeholders/Division of Parks.)

The tennis court was added in the early 1900s in the north garden area and was not part of the original design. Behind the fence and bench is the grape arbor, which was originally part of a larger fruit garden. In the background are the barn and part of the mansion annex. The cast-iron trellis was built by H.B. Smith Machine Company workers. Today, the grapevine-covered pathway is used by wedding photographers as a setting for bride and groom portraits. (Above, courtesy of the Burlington County Board of Chosen Freeholders/Division of Parks; right, courtesy of James Denworth.)

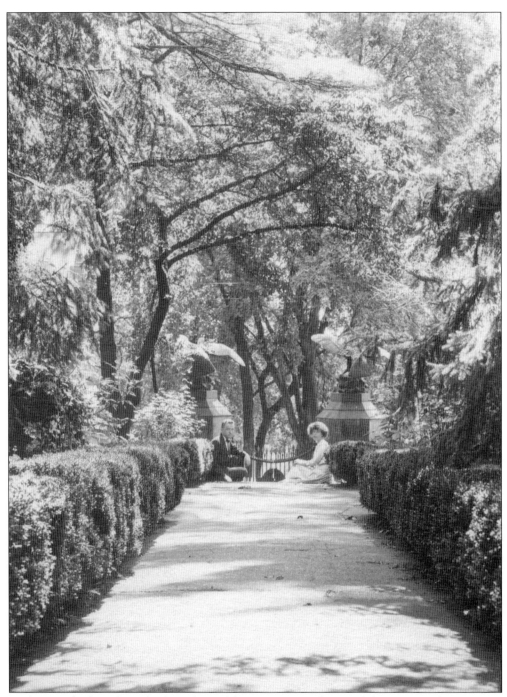

In this view looking from the front door of the mansion south toward the iron-gated entrance, a couple sit on the walkway steps in the early 1900s. Behind them are the cast-iron eagles on either side of the entrance. The young boxwood hedges on either side of the front walkway make for an open appearance. (Gift of Jane Challender, courtesy of the Friends of the Mansion at Smithville.)

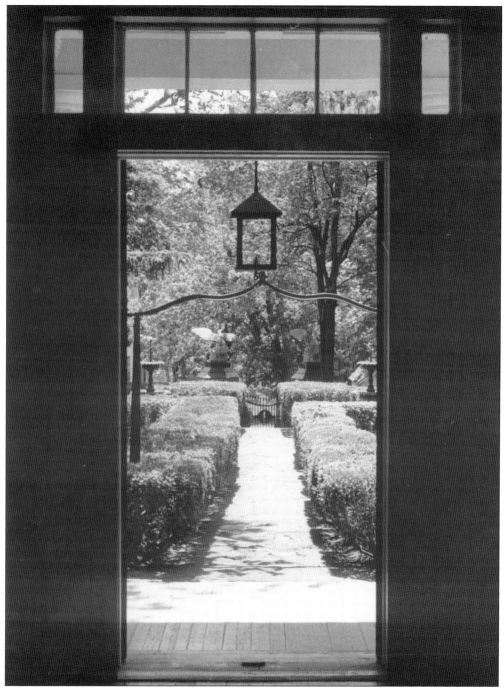

A similar view from the late 1970s looks from inside the front door of the mansion toward the iron-gated entrance with the cast-iron eagles on either side. The boxwood hedges have overgrown the front walkway and make it more intimate. (Photograph by Thomas M. Barnett, courtesy of the Burlington County Board of Chosen Freeholders/Division of Parks.)

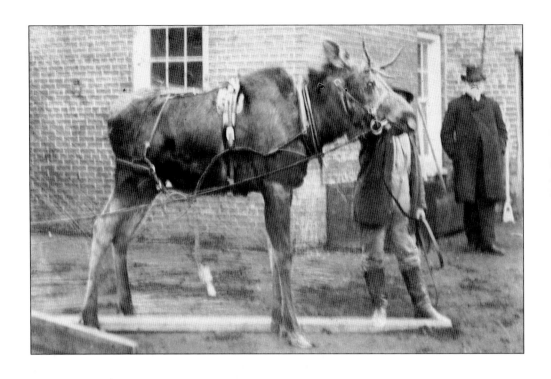

Above, Hezekiah Smith (right) looks at his moose February that he captured while on a hunting trip to New Brunswick, Canada, in 1885. Smith often went on hunting trips to collect animals for his menagerie, including deer, caribou, and elk. The animals were housed inside the expanded, walled grounds of the mansion. Smith employee John Dobbins harnessed the moose and trained it to pull a cart. The pair were often seen on the roads around Smithville and Mount Holly during training runs. (Both, courtesy of the Burlington County Board of Chosen Freeholders/Division of Parks.)

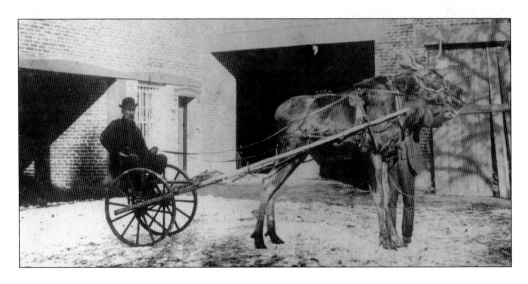

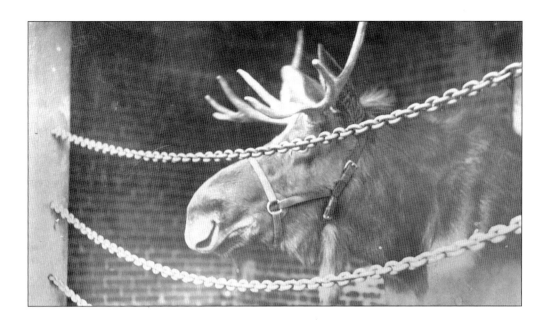

February the moose was kept in the stable where H.B. Smith housed his horses. In 1887, Smith bought a two-year-old female moose while in New Hampshire to add to his game preserve and keep February company. Driver John Dobbins exercised February on Smithville Road outside the mansion walls. Stories from the time have Dobbins and February competing in harness races at the Great Burlington County Fair in Mount Holly, New Jersey. (Both, courtesy of the Burlington County Board of Chosen Freeholders/Division of Parks.)

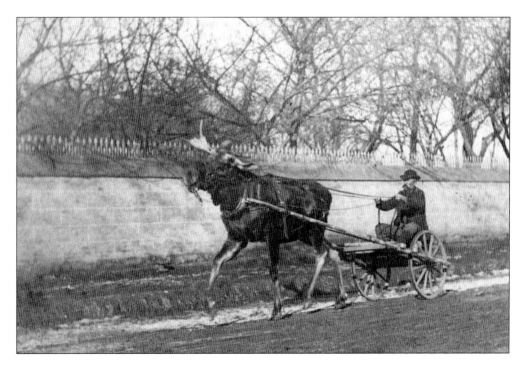

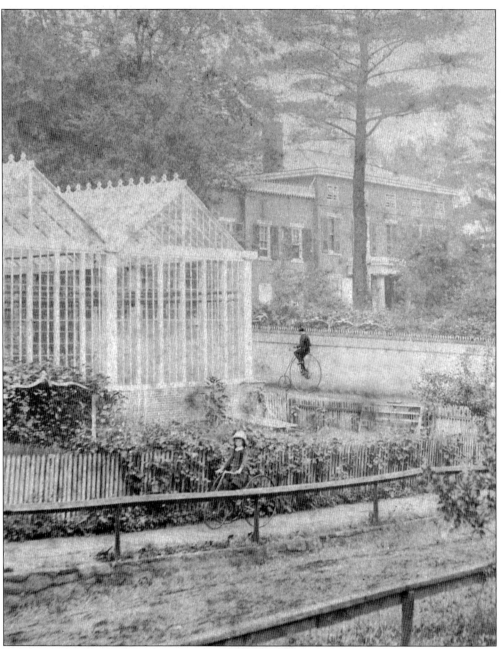

An American Star bicycle rider travels uphill past the walled Smithville Mansion with the conservatory at left. The American Star was designed by George Washington Pressey and built at the H.B. Smith Machine Company factory beginning in 1881. The company produced variations on the standard bicycle, including tricycles, women's safety bicycles, and children's bicycles and tricycles. A young girl rides a child's Star tricycle in the foreground. The cast-iron conservatory was 55 feet by 70 feet and 20 feet high. It was finished in 1883 and managed by the gardener Fritzy Gsell. The conservatory housed exotic tropical and subtropical plants and was said by visitors to have tropical birds flying inside. (Courtesy of the Friends of the Mansion at Smithville.)

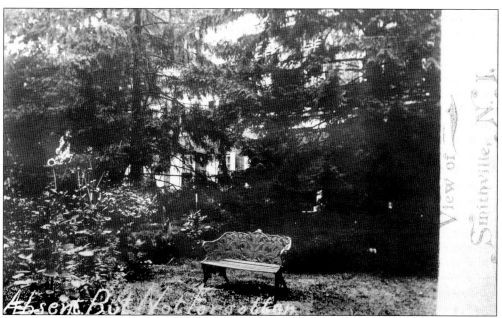

The postcard above from the early 1900s shows part of the formal gardens surrounding the mansion. They contained numerous statues, benches, fountains, and flower urns. Many of the cast-iron benches and urns were built by craftsmen at the H.B. Smith Machine Company. Gardener Fritzy Gsell planned and maintained the gardens inside the mansion walls and inside the conservatory. At right, a pair of dogs guard one of the stairways in the south garden. (Above, author's collection: right, courtesy of James Denworth.)

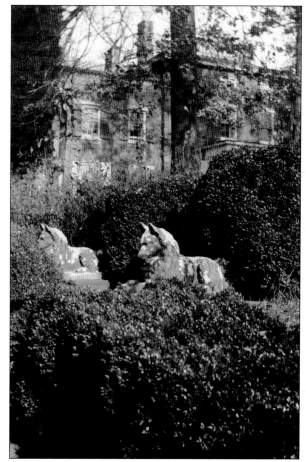

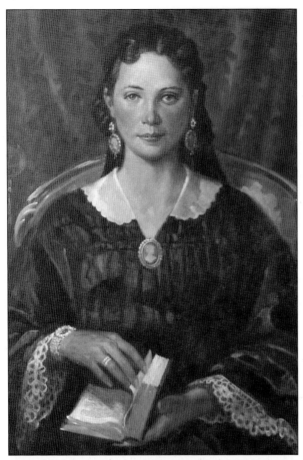

Agnes Gilkerson Smith ran a household full of servants, was a graduate of Penn Medical University specializing in herbal treatments, edited and wrote for the H.B. Smith Machine Company publication *New Jersey Mechanic*, and worked with her husband to implement their ideas for an ideal worker's village. The Smiths often took part in discussions, poetry readings, and other entertainment at the Lyceum. (Left, courtesy of the Friends of the Mansion at Smithville; below, courtesy of the Burlington County Board of Chosen Freeholders/Division of Parks.)

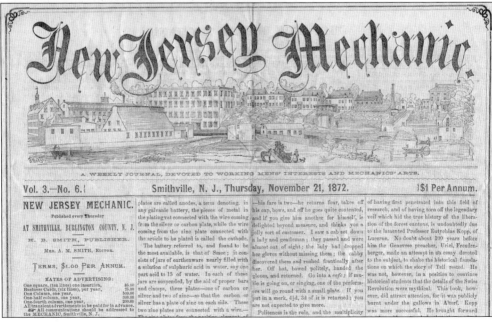

MADAM SMITH'S
CELEBRATED
HAIR RESTORER
AND BEAUTIFIER,

Produces a vigorous growth of hair, together with a soft, glossy and beautiful appearance; prevents it from falling off; prevents baldness and premature grayness.

Try a bottle and you will never be without it.

Nothing preserves youthful looks like a handsome head of hair. One of the most valuable preparations of the kind ever offered to the public. All who have used it speak in the highest praise of its merits. Warranted to contain no injurious ingredients.

No humbug about it; but based upon sound scientific principles. There has long been a demand for just such an article; and particularly at the present time, when ninety-nine ladies out of a hundred, have lost, or are losing their hair. Hair falls off, refuses to grow again, and turns permaturely gray, because it lacks proper nourishment; because injurious obstructions have accumulated around the roots and pores; and because it requires healthy stimulation. Madam Smith's Hair Restorer remedies this.

Madam Smith is a graduate of a medical college, something of a chemist, and also possessed of ample means to live at her ease; but having tried to no purpose, various preparations for invigorating her own hair, preventing it from falling off, and arresting premature grayness, she determined on getting up something that would bring about this desideratum. The result of her labors, is the discovery of a sovereign remedy, which she has finally consented to offer to the public.

☞ For further information, address,
MADAM SMITH, M. D.,
Smithville, Burlington Co., N. J.

Feb. 2, 1871—tf

Agnes Smith developed various herbal medicines and remedies, one of which was advertised in the *New Jersey Mechanic*. In January 1881, Agnes, Hezekiah's wife of 25 years, died from cancer. In 1886, a commissioned statue of Agnes arrived from Italy and was placed in the south garden. The statue was located in a favorite reading spot of hers, facing the company farm. Unfortunately, after Hezekiah's death in 1887, his son Elton had the statue smashed and the remnants thrown into Rancocas Creek. (Both, courtesy of the Burlington County Board of Chosen Freeholders/Division of Parks.)

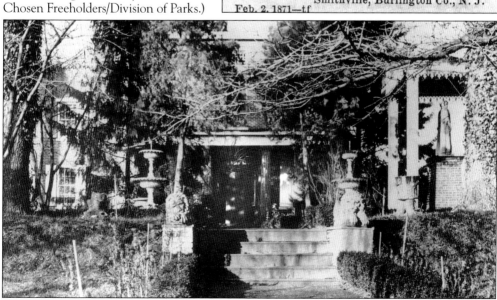

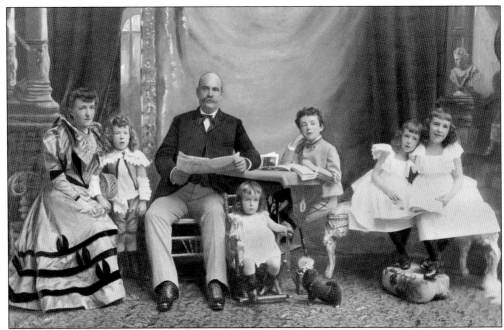

Elton A. Smith, son of Hezekiah Smith, poses with his family in 1895 while they were living in Savannah, Georgia. From left to right are Mary O'Byrne Smith, Erle Smith Jr. (age 5), Elton, Eveline Verona Smith (age 3), Elton Allen Smith Jr. (age 9), Hilda Smith (age 7), and Regis Smith (age 11). (Courtesy of the Burlington County Board of Chosen Freeholders/Division of Parks.)

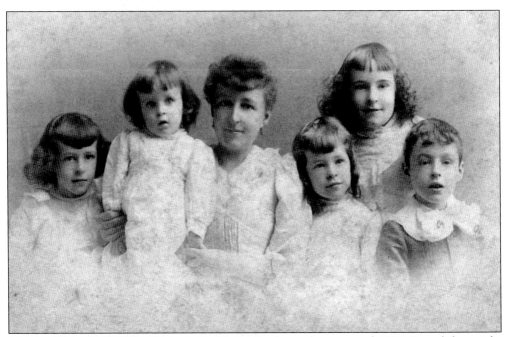

This studio portrait of the Elton A. Smith family shows them around 1890. From left to right are Eveline Verona, Elton Allen Jr., Mary O'Byrne Smith, Hilda, Regis, and Erle. The family was living in Savannah at the time of this photograph. (Courtesy of James Denworth.)

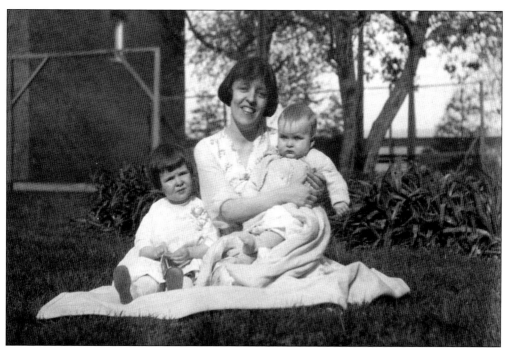

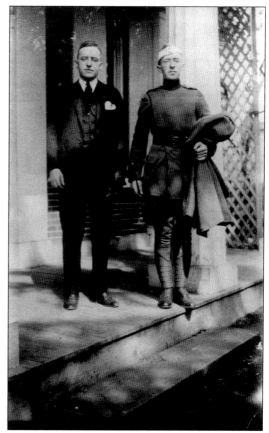

Verona Smith Pie poses with her daughter Clair (left) and her son Justin Allen in the north garden near the tennis court around 1918. Justin Allen Pie died in World War II. Verona Smith Pie's brothers Elton Allen Smith and Erle J. Smith, in his Royal Canadian Air Force uniform, are pictured at right on the porch of the Smithville Mansion in 1916. Clair, Elton, and Erle were the grandchildren of Hezekiah B. Smith. He probably never met any of them since he was estranged from his children from his first marriage. (Above, courtesy of Jim Denworth; right, courtesy of the Burlington County Board of Chosen Freeholders/Division of Parks.)

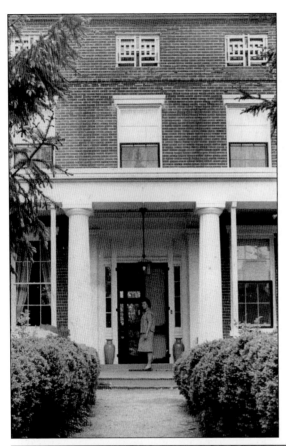

Grace Thomas stands on the front porch of the Smithville Mansion in 1965. She and her husband, Louis, purchased the house from the Smith family in 1961. They were the first nonfamily members to live in the mansion in almost 100 years. Together, they renovated the property and turned some of the outbuildings into apartments. Below, Grace looks over a book with a friend in the downstairs family parlor. (Both, courtesy of the Burlington County Board of Chosen Freeholders/Division of Parks.)

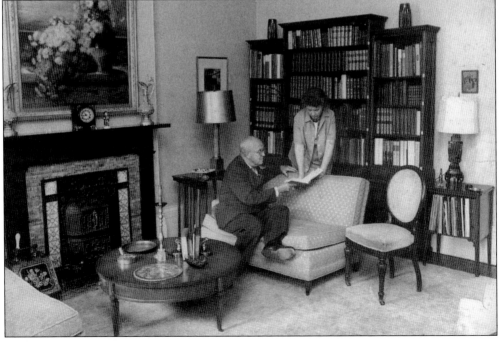

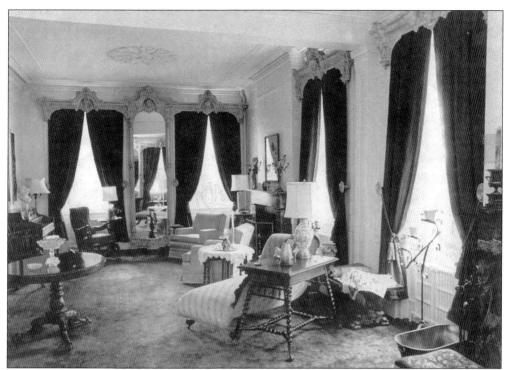

The double parlor is the largest room in the mansion. Hezekiah and Agnes renovated the home after it sat empty when the Shreve family moved out in 1855. Hezekiah contracted to have the pier mirrors and cornices constructed in Philadelphia and installed in the late 1860s. The formal room was probably used to entertain guests. Agnes Smith's bedroom is seen below. These photographs date from the 1960s and do not reflect how the rooms were decorated when Hezekiah and Agnes lived there. (Both, courtesy of the Burlington County Board of Chosen Freeholders/Division of Parks.)

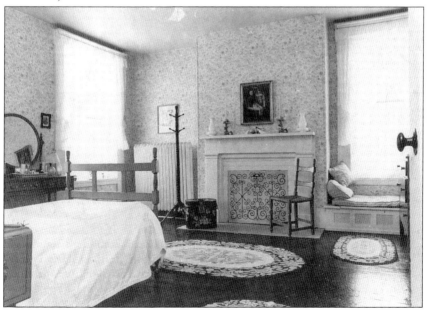

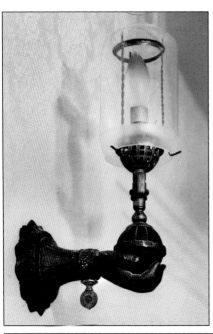

This unique, original light was used in the bowling alley in the mansion annex. The fixture representing a hand holding a ball was made by the craftsmen at the Smith Machine Company. It was donated by Grace Thomas when she sold the mansion to the county. (Photograph by Thomas M. Barnett; courtesy of the Burlington County Board of Chosen Freeholders/Division of Parks.)

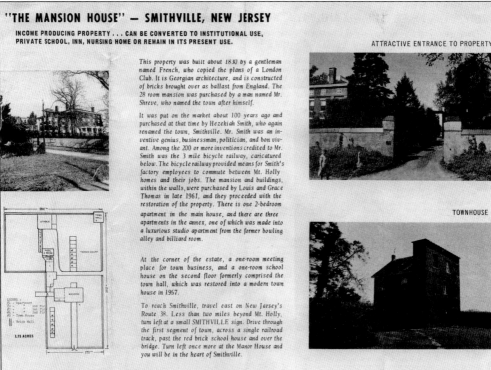

This real estate brochure from the early 1970s shows the mansion, the grounds, and the outbuildings offered for sale by Grace and Louis Thomas. The property was listed for $165,000. The Burlington County Freeholders purchased the property in 1975 along with much of the surrounding village. It became Burlington County's first park. (Courtesy of the Burlington County Board of Chosen Freeholders/Division of Parks.)

Two
SMITHVILLE VILLAGE

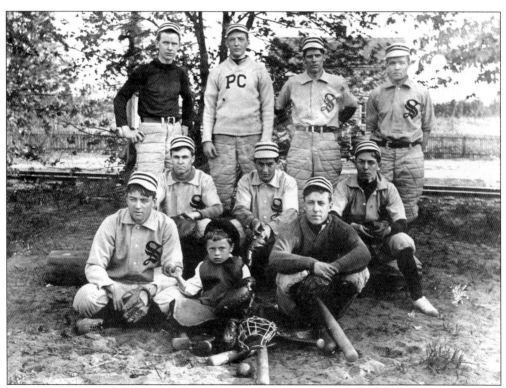

The 1904 Smithville baseball team poses for a photograph near the railroad tracks in the lower village. From left to right are (first row) Ernest Martin, Allen Smith, and Joseph S. Craig; (second row) Walter Harker, Frank Harker, and Len Stilts; (third row) Millard Bomers, Charlie Holzbow, Russell Finley, and John Ross. They played teams from New Egypt, Birmingham, and Columbus and traveled by train to the games. (Donated by Jane Challender, courtesy of the Friends of the Mansion at Smithville.)

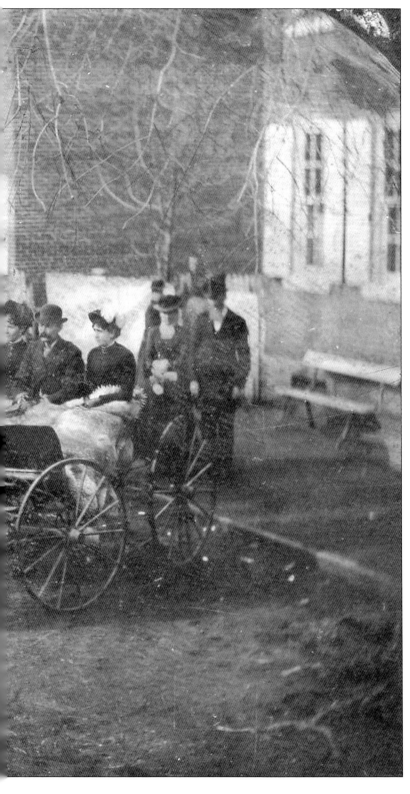

A carriage heads for an outing on Maple Avenue in Smithville in the 1870s. In the carriage are John Henry Willard; his wife, Emma Louise (Roberts) Willard (left); and her mother, Phoebe Roberts. Walking behind the carriage are Joseph and Mary (Hosier) Willard. The row of brick houses was built in the style of the mansion when the town was called Shreveville. Hezekiah B. Smith bought the property and named it Smithville in 1865. Smith kept this row of duplexes when he began to renovate the upper village because the interior size of the three-story buildings fit the standards he thought worker's houses should meet. (Courtesy of Richard Mahn.)

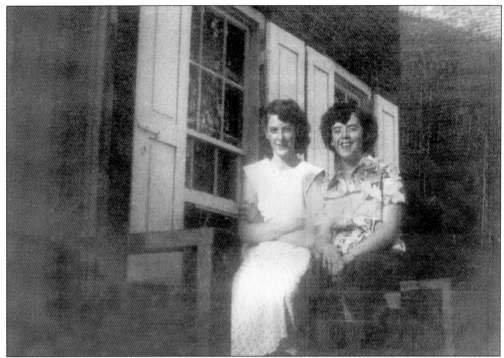

Above, Ella Oatman (right) and a friend sit on the railing of a house on Maple Avenue. The houses built in the 1840s by the Shreve brothers lasted well into Smith's ownership. They were three stories and contained a sitting room, a dining room, and kitchen shed, and the upper floors contained two bedrooms each. The stone wall seen in the photograph below, taken around 1900, is the only element of the scene remaining today at Smithville. Where the houses stood is now a parking lot. (Both, courtesy of the Burlington County Board of Chosen Freeholders/Division of Parks.)

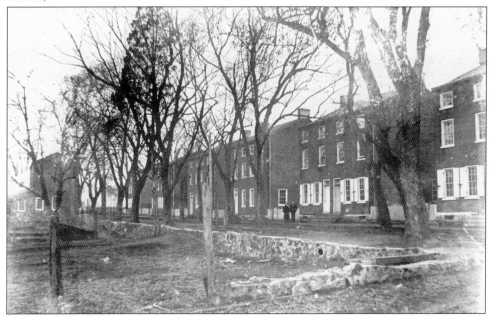

Workers at the H.B. Smith Machine Company lived in these homes into the late 1940s. According to William Bolger in *Smithville: The Result of Enterprise*, the three-story homes were the handsomest and were built with brick to match the mansion. The houses were located close to the street and the yards were quite small, with privies at the rear. By 1948, when the photograph below was taken by N.W. Ewan, the houses were past their prime, and they were leveled shortly thereafter. (Both, courtesy of the Burlington County Board of Chosen Freeholders/ Division of Parks.)

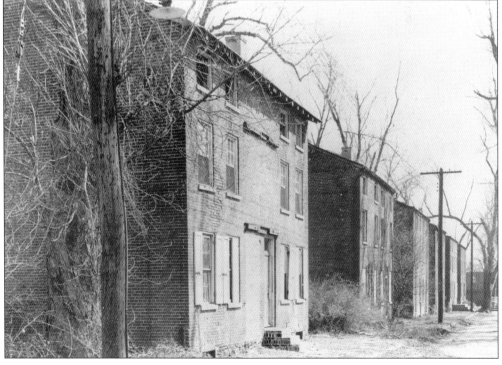

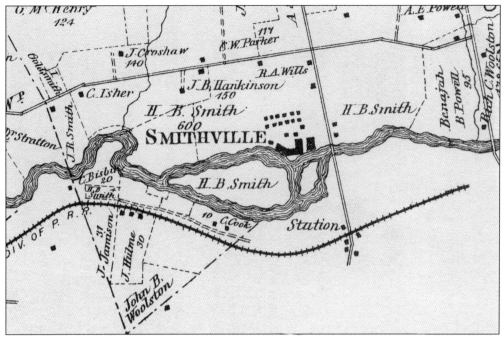

This map of Smithville shows the lands owned by Hezekiah B. Smith, Rancocas Creek, and the railroad. The island with Smith's name on it was where the factory was located. The illustration below shows an idealized view of North Smithville, including Smithville Road, the millpond, the factory complex (at left), the farm complex (at right), the mansion, and the worker's houses in the upper village. Author William Bolger, in *Smithville: The Result of Enterprise*, states that a small steamboat ran between the Smithville pond and the dam at Birmingham in 1875 at reduced fares. The steamboat was owned by Joseph Wills, and a boathouse was built on the pond to house the pleasure boat. (Both, courtesy of the Burlington County Board of Chosen Freeholders/Division of Parks.)

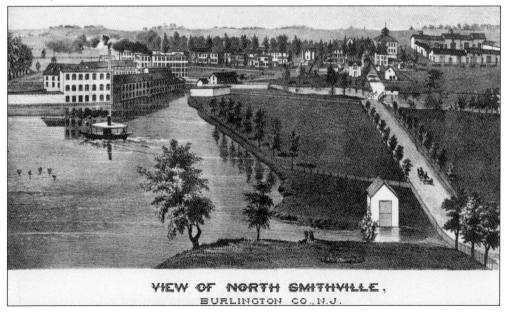

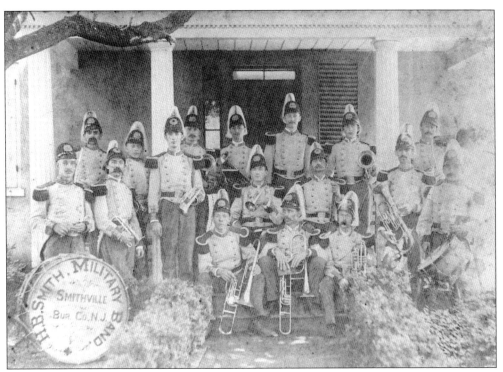

The H.B. Smith Military Band numbered about 20 members, with instruments and tailored uniforms purchased by Smith. Under the leadership of Prof. H.A. Raymond, the band performed throughout the county and the state and became known as one of the best. Below is an invitation to a concert given by the orchestra in Smith's Forest. Smith's Forest, located to the east of Smithville Road and now known as Smith's Woods, was a place for worker's families to relax on Sundays. The band also performed in the upper village gazebo and in the opera house in Mechanics House. (Both, courtesy of the Burlington County Board of Chosen Freeholders/Division of Parks.)

Musical Entertainment.

The pleasure of the company of Yourself and Ladies is requested by "The H. B. Smith Military Band," at their Musical Entertainment, in Smith's Forest,

On Saturday Afternoon and Evening, August 26.

A good Orchestra will be in attendance during the Evening. Refreshments will be served on the Grounds.

 H. B. SMITH, G. O. HALL,
 JOS. J. WHITE, JOHN SALTAR, JR.
 DAVID H. AARONSON,

Smithville, Aug. 21, 1876. *Committee of Arrangements.*

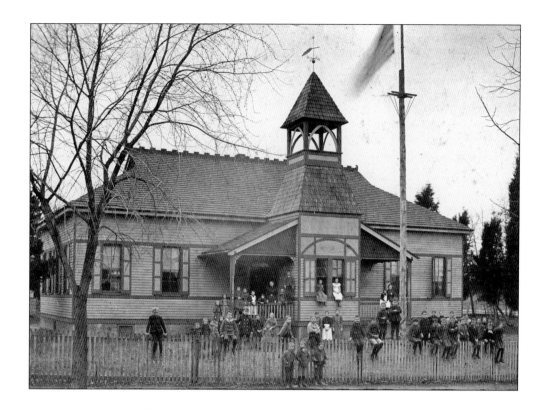

The two-room frame schoolhouse was built by Eastampton Township in 1906, enlarged in 1925, and covered in a brick veneer in 1940. The building was no longer used as a school in the 1960s. As late as 2017, it housed the Eastampton Township police office and municipal court. The 1925 second-, third-, and fourth-grade class portrait below was taken on the playground behind the school. (Above, courtesy of the Friends of the Mansion at Smithville; below, courtesy of Kim and Wayne Batten.)

Eastampton Township issued a commemorative plate in 1980 celebrating its 100th anniversary. The former school building was also used as a town hall, police station, and municipal court and is currently used by the township's public works department. (Courtesy of the Burlington County Board of Chosen Freeholders/Division of Parks.)

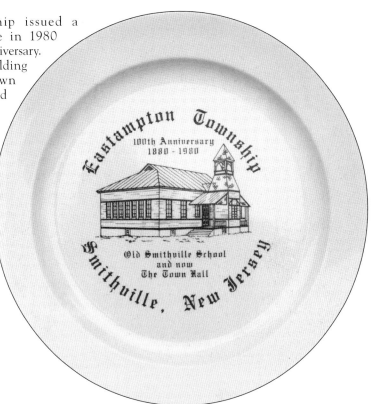

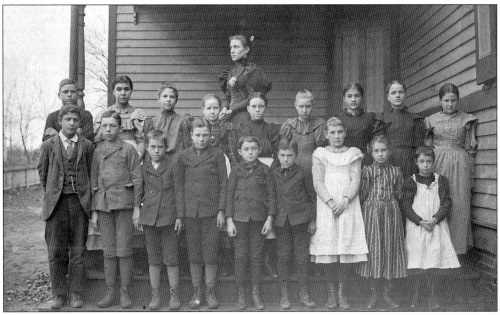

In this class portrait, older students and their teacher stand to the side of the building in their best clothes. The new school had only two classrooms. The students were divided into upper and lower grades. The only student identified in the photograph is Elvin H. Norcross, standing at left in the front row. (Courtesy of the Friends of the Mansion at Smithville.)

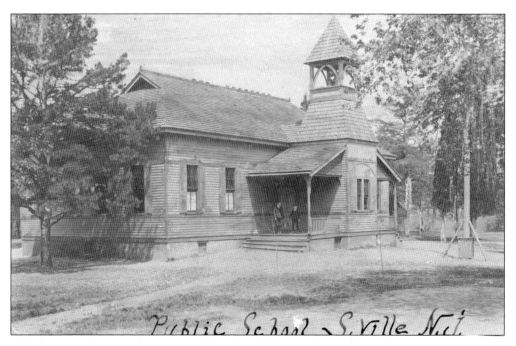

Above, two students stand on the front porch of the Smithville School in Eastampton, New Jersey, holding a bucket in this postcard from the early 1900s. The new school, with a bell tower used to summon the students, was located in the southern part of the village on Smithville Road. The former schoolhouse had been in the northeast corner of the mansion property but was forced to close due to inadequate ventilation and lighting. Below, students in the lower grades stand on the steps of the schoolhouse with their teacher. (Above, courtesy of the Burlington County Board of Chosen Freeholders/Division of Parks; below, courtesy of the Friends of the Mansion at Smithville.)

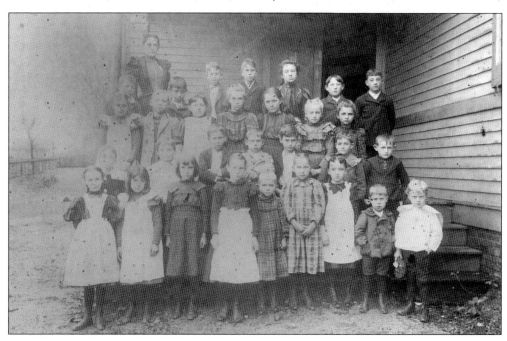

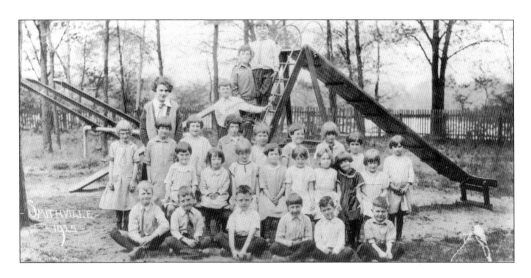

The playground in the back of the Smithville School was the setting for the first-grade class portrait above in 1925. Opened in 1906, the Smithville Schoolhouse was raised in 1938, and a new block foundation replaced the old brick one. The school had grown and now had three classrooms, indoor toilets, a kitchen, lockers, an auditorium with a stage and curtains, and a bicycle shed for the students. The school closed in 1963 when a new school opened on Smithville Road. The photograph below was donated by Miriam Pickett Haines, a former teacher at the Smithville School. (Both, courtesy of the Burlington County Board of Chosen Freeholders/Division of Parks.)

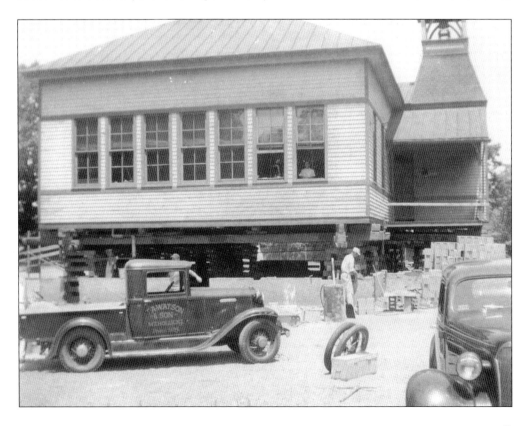

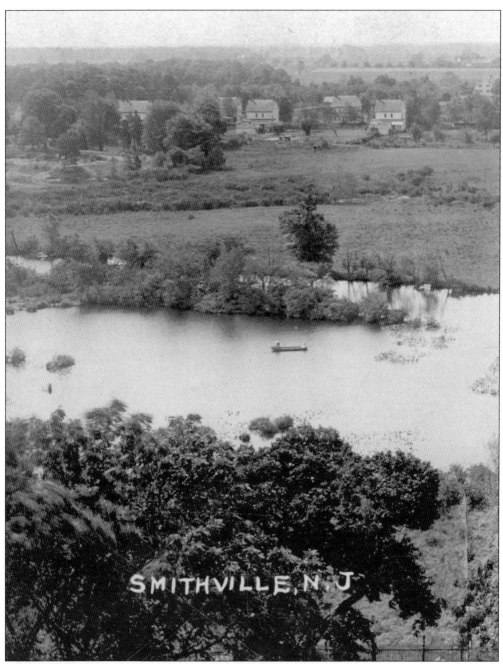

This view looking across the north branch of Rancocas Creek from the observation tower shows the southern part of the village of Smithville. The newer section of the village contained additional workers' houses, the Methodist church, the train station, the school, and a warehouse for packaging woodworking machines and American Star bicycles for shipment by rail. (Author's collection.)

The Methodist church is located in the lower village of Smithville. The church members had worshipped in the Shreveville Schoolhouse, but attendance dwindled when the Shreve brothers closed the cotton mill. When Hezekiah Smith purchased the village and mill in 1865, the church once again increased in members and needed a new building. The church was erected in 1877 with a donation of land from Smith. A parsonage was built next door as a home for the minister and his family. (Right, courtesy of Sheila D'Avino; below, courtesy of the Burlington County Board of Chosen Freeholders/Division of Parks.)

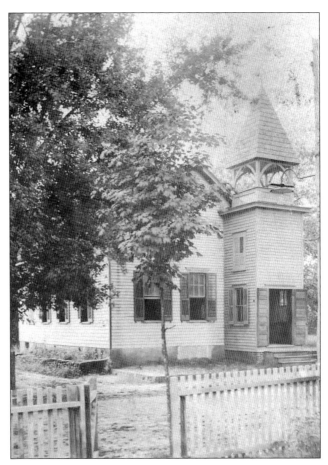

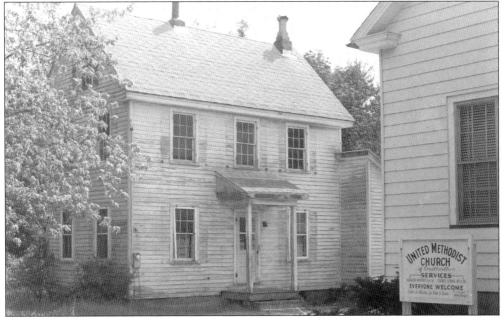

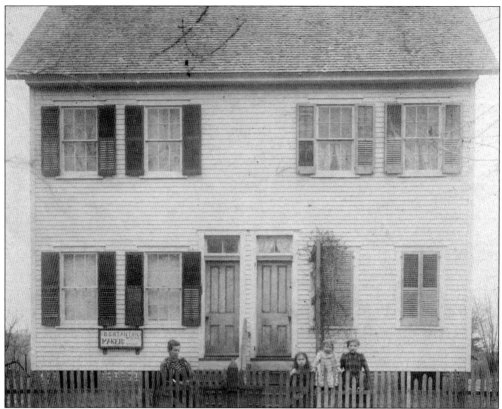

The photograph above of a twin house on Forrest Avenue in the lower village of Smithville shows a woman and three girls standing near the fence in front. A sign on the left side of the duplex reads, "D.G. Stanton, Maker of Brooms and Whisks." Below is a view looking north at Smithville Road, with an X marking the home of the Willard household. All the houses in the newly constructed lower village had picket fences in front. The houses on Smithville Road also had newly planted maple trees. (Above, courtesy of the Friends of the Mansion at Smithville; below, courtesy of Richard Mahn.)

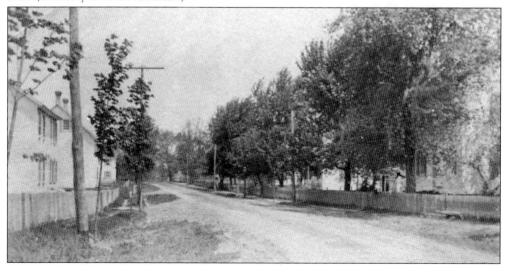

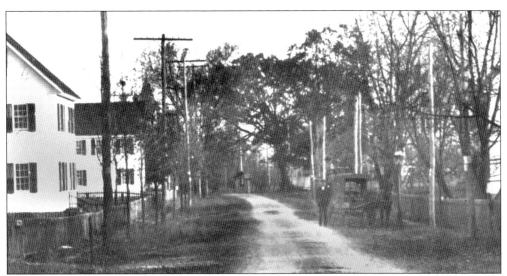

The view above looking north on Smithville Road in the lower village of Smithville shows a horse and carriage with a man beside it and a railroad watchman's building at the railroad crossing. The rear view of the house at 35 Forest Avenue below shows clothes drying on the line, a garden, and two children playing in the yard with women nearby. Open space was important when H.B. Smith designed these newer houses. They were built alternating on opposite sides of the street to give the impression of more open space around them. (Both, courtesy of the Burlington County Board of Chosen Freeholders/Division of Parks.)

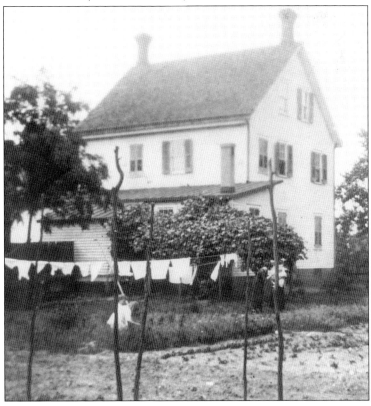

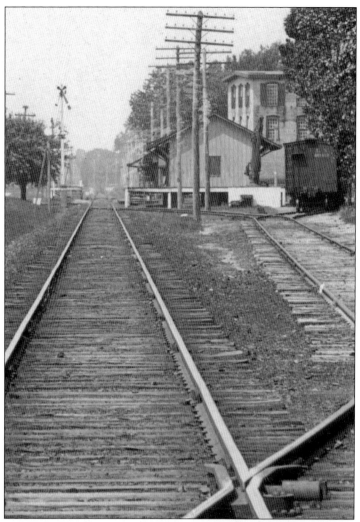

The Burlington County Railroad carried both passengers and freight on the rail line that traveled through Smithville. In the background is the three-story H.B. Smith Machine Company warehouse. Most woodworking machines and American Star bicycles were stored and shipped by rail from this building. Below is an image of the passenger station with another view of the company warehouse. This station was built in 1884 and replaced an earlier structure. The passenger and freight station and warehouse were located in the lower village of Smithville. (Left, courtesy of the Friends of the Mansion at Smithville; below, courtesy of the Burlington County Board of Chosen Freeholders/Division of Parks.)

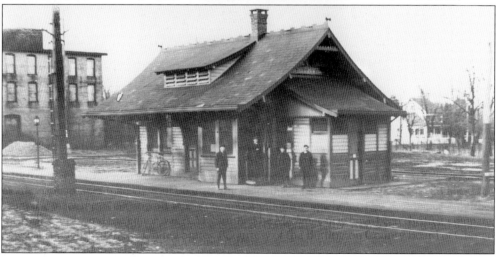

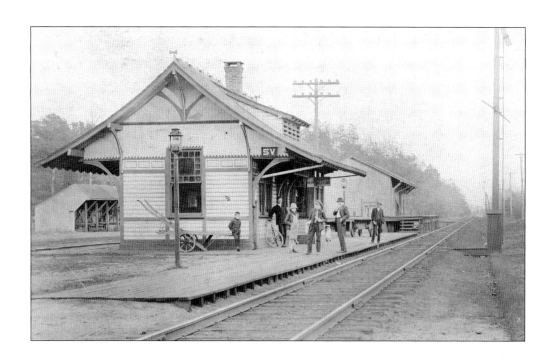

Passengers and freight could travel to Philadelphia by railroad in a little over an hour in 1887 with the Pennsylvania Railroad Company. The passenger station was located about a half mile from the H.B. Smith Machine Company buildings. Some workers at the factory commuted by train from Mount Holly to Smithville in the late 1800s. Eventually, H.B. Smith purchased all the land surrounding the railroad station and built new housing for his workers. (Above, author's collection; below, courtesy of the Burlington County Board of Chosen Freeholders/Division of Parks.)

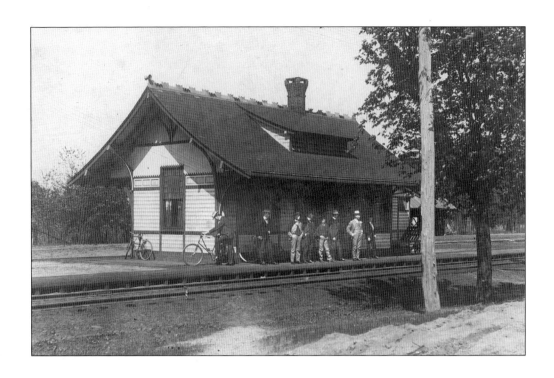

Above, passengers wait on the platform at the Smithville train station in 1901. Those boarding at Smithville could reach surrounding towns such as Mount Holly, Moorestown, Pemberton, and Whiting without switching trains. Access to Philadelphia required taking a ferry across the Delaware River. The view in the photograph below looks south on Smithville Road and shows the train station, the Methodist church, and a platform loaded with milk cans. Philadelphia got 60 percent of its milk from South Jersey. (Both, courtesy of the Friends of the Mansion at Smithville.)

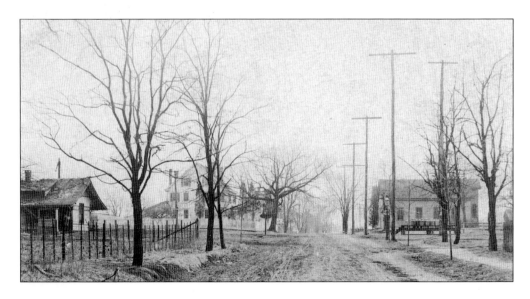

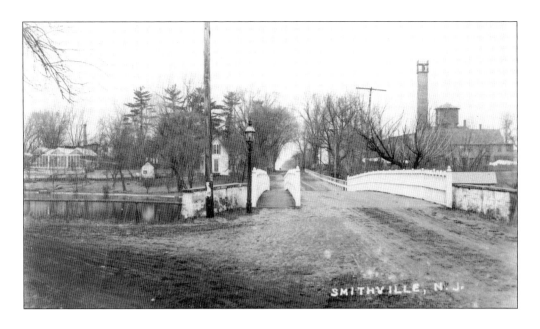

Above, this sweeping, panoramic view of Smithville looking north on Smithville Road shows, from left to right, the conservatory/greenhouse, Semple Cottage, the ornate main bridge with a walkway over Rancocas Creek, the observatory tower, and the farm buildings at right. The road before the bridge at left goes directly to the H.B. Smith Machine Company factory. This bridge was replaced in 1914 by a structure with a concrete deck. Below, sitting on the newer bridge with galvanized pipes as railings are Helen Fenimore (right) and some unidentified friends. (Both, courtesy of the Burlington County Board of Chosen Freeholders/Division of Parks.)

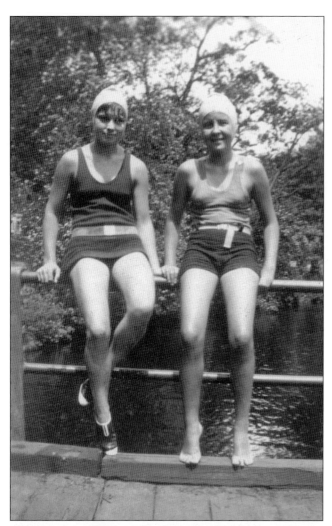

Rancocas Creek and the pond formed by damming it provided activities for residents of Smithville year-round, including swimming, fishing, boating, and ice-skating. At left, swimmers Clair Pie (right) and an unidentified friend sit on the railing of a bridge over the creek above the dam. Below, Clair's brother Billy Pie (left), skates with friends on the frozen millpond with the H.B. Smith Machine Company factory behind them. The Pie children were great-grandchildren of Hezekiah Bradley Smith, the founder of Smithville. (Left, courtesy of James Denworth; below, courtesy of the Burlington County Board of Chosen Freeholders/Division of Parks.)

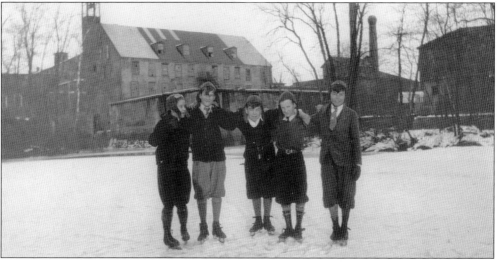

J.H. Wills steers a Barnegat Sneakbox on Rancocas Creek above the dam, with the H.B. Smith factory Machine Shop No. 1 in the background. Damming the creek supplied power to the company but also allowed the residents to enjoy outdoor activities. Smith's planned community with parks, walkways, and play areas allowed residents of Smithville to enjoy their time off from work at the factory. (Right, courtesy of the Burlington County Board of Chosen Freeholders/Division of Parks; below, courtesy of the Friends of the Mansion at Smithville.)

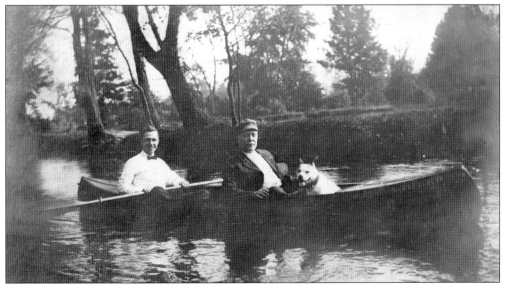

This view looking across the north branch of Rancocas Creek from the factory complex shows the upper village of Smithville. From left to right are the wooden worker's houses, the greenhouse/conservatory, the bandstand/gazebo, and the observation tower with the old farmhouse. (Courtesy of the Friends of the Mansion at Smithville.)

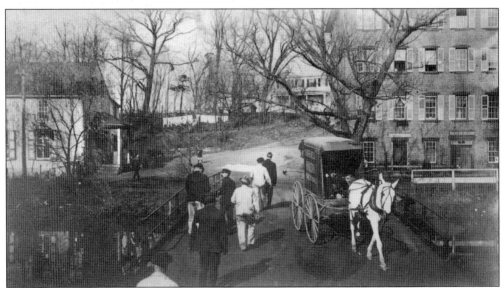

This view of the main bridge from the factory looks across Rancocas Creek toward the general store (left), the worker's houses, and the Mechanics House (right). The bridge allowed quick access to work and allowed the workers to go home for lunch. (Donated by Jane Challender, courtesy of the Friends of the Mansion at Smithville.)

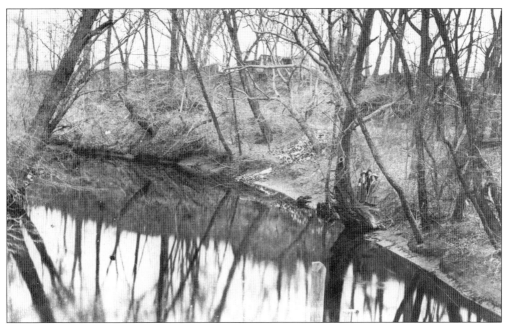
Helen Fenimore and friends stand on the roots of a tree extending over Rancocas Creek in the early 1900s. This view hasn't changed over the years. The creek provided recreation, a scenic view, and waterpower for the factory. (Courtesy of the Burlington County Board of Chosen Freeholders/Division of Parks.)

A woman leans on a fence running along River Street, with Rancocas Creek, the millpond, and part of the H.B. Smith Machine Company factory in the background. This view is what a worker would see from the front window of his frame house. (Courtesy of the Burlington County Board of Chosen Freeholders/Division of Parks.)

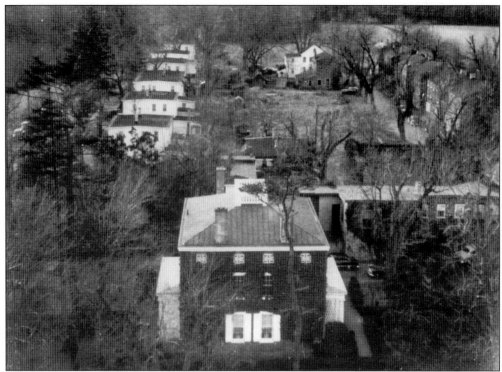

This view of the upper village from the observation tower shows the worker's houses in relation to the mansion (foreground). At top left are the white frame houses built by Hezekiah Smith soon after he arrived in Smithville. The three-story brick houses at top right were built by the Shreve brothers and were close to 100 years old when this photograph was taken in 1945. (Courtesy of the Burlington County Board of Chosen Freeholders/Division of Parks.)

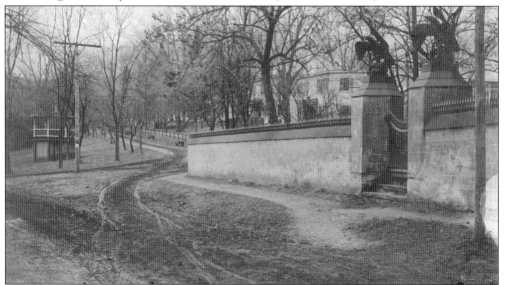

At the corner of Front Street and Smithville Road is the entranceway to the Smith mansion. Down the dirt road are the worker's houses, with the gazebo at left. The view today has not changed, except that the road has been paved. (Courtesy of the Friends of the Mansion at Smithville.)

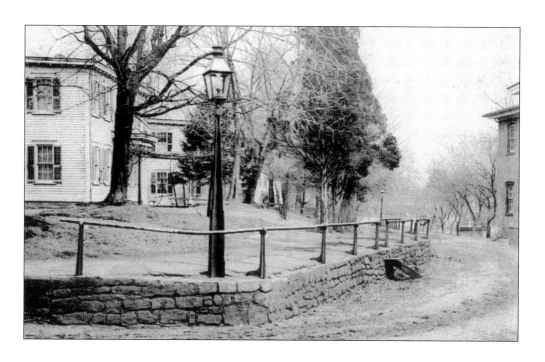

Both views look east on Park Avenue toward Smithville Road, one from the top near the curve and the other near where it meets Front Street/River Road. On the left are the wooden worker's houses, and part of the Mechanics House is shown on the right. When orders for woodworking machines were slow at the H.B. Smith Machine Company, the machinists produced iron products for the village, such as the iron railings and steps seen here. They are part of the village to this day. (Both, courtesy of the Burlington County Board of Chosen Freeholders/Division of Parks.)

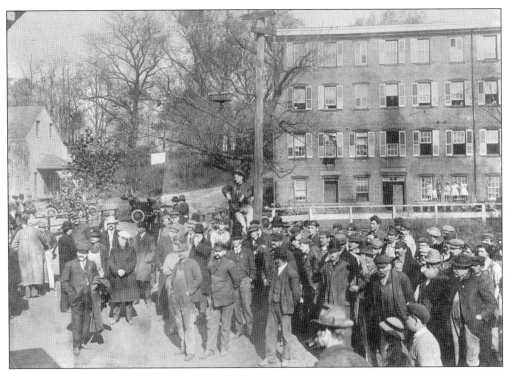

In October 1908, the workers at the H.B. Smith Machine Company attended a political rally near the bridge above the dam near the Mechanics House in Smithville. The four-story building housed single men and apprentices who worked at the factory. The bridge across the creek connected the factory to the workers' residences. The ground floor of Mechanics House contained a butcher shop, barbershop, produce stand, and oyster saloon. The second floor contained a dining hall that served workers crossing the bridge to eat lunch nearby. (Above, courtesy of the Friends of the Mansion at Smithville; below, courtesy of the Burlington County Board of Chosen Freeholders/Division of Parks.)

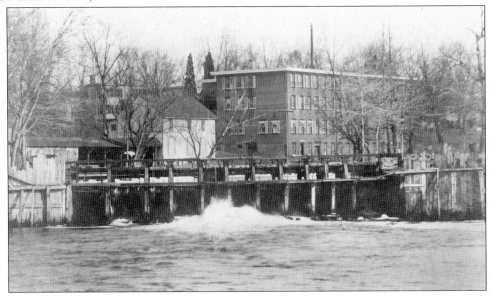

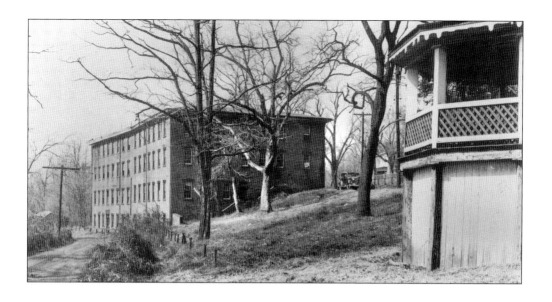

The view down River Road above shows the Mechanics House in the background and the band gazebo in the foreground at right. This open area between the houses and Rancocas Creek, along with the Mechanics House, was the hub of the village. The park area by the gazebo provided open land for the families of the workers to play, and the gazebo gave the 20-piece H.B. Smith Military Band a place to perform. The Mechanics House contained shops, reading rooms, a billiard room, a dining room, and an opera hall where the band also played. (Both, courtesy of the Burlington County Board of Chosen Freeholders/Division of Parks.)

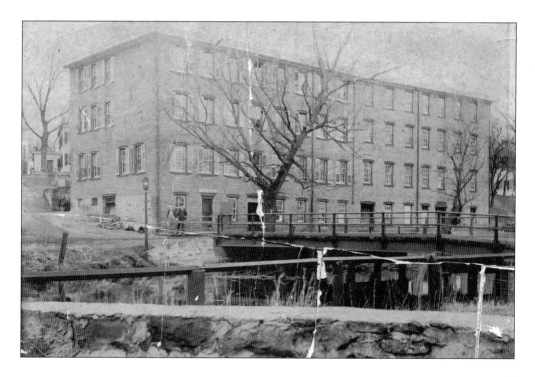

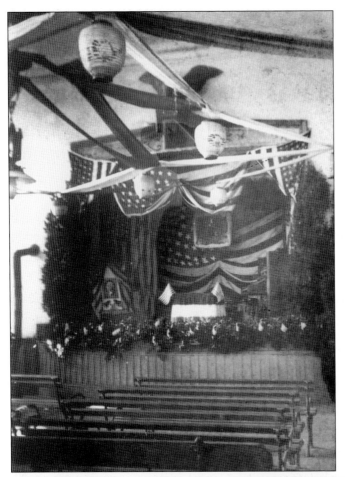

The auditorium inside the Mechanics House was the center of entertainment for the village of Smithville. The Mechanics House opened in 1870, and the opera hall was added in 1875 so entertainment could be provided year-round. The eagle-topped stage surrounded by flags was the centerpiece of the auditorium. The chairs and benches were not attached to the floor so that they could be moved out of the way for dances. (Both photographs donated by Barbara and Everett Turner, courtesy of the Burlington County Board of Chosen Freeholders/Division of Parks.)

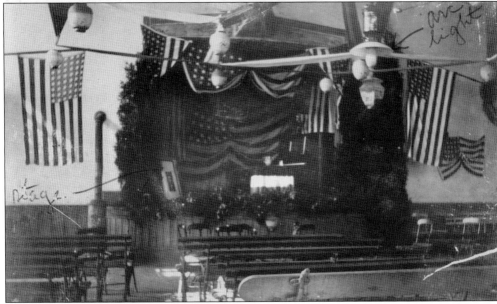

> The pleasure of your company is requested at the
> ## Thursday Evening Dances
> to be given in the
> ## Opera House, Smithville, N. J.
>
> Music by the Imperial Orchestra
>
> Opening Dance, September 21, 1911
>
> Ladies, 25 cents Gentlemen, 25 cents
>
> Andrew F. Waltz Floyd S. Stockton
> Walter H. Cotton J. Wilmer Hoffman

Dances, orchestral performances, readings, and concerts by the H.B. Smith Military Band all took place in the Mechanics House Opera Hall throughout the years. The ornate railing on the balcony was designed and built by the craftsmen at the H.B. Smith Machine Company. The invitation above was to Thursday evening dances given in the opera house, with the opening dance on September 21, 1911, one of the many activities that took place there. The opera house was the village centerpiece when it opened in 1875. Less than 75 years later, both the opera house and Mechanics House were demolished. (Both, courtesy of the Burlington County Board of Chosen Freeholders/Division of Parks.)

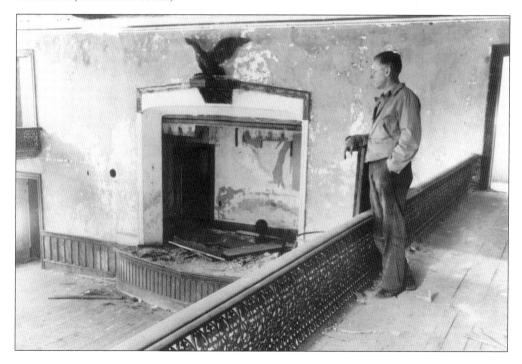

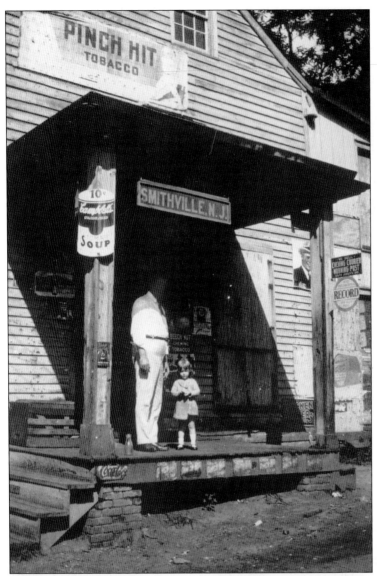

At left, standing on the porch of the Smithville general store are postmaster Alfred Johansen and his daughter. The store housed the Smithville Post Office while Johansen was postmaster. It burned to the ground shortly after Johansen was relieved of his post in 1930. The local post office was established in 1866 shortly after H.B. Smith bought the Shreve property. The postal letterhead below from the late 1800s shows William S. Kelley as postmaster. Kelley later became the president of the H.B. Smith Machine Company after the death of Hezekiah B. Smith. (Both, courtesy of the Burlington County Board of Chosen Freeholders/Division of Parks.)

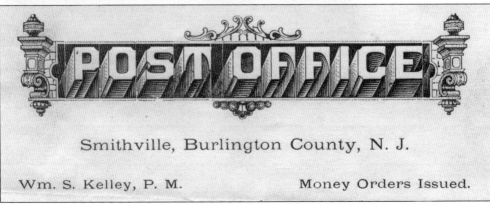

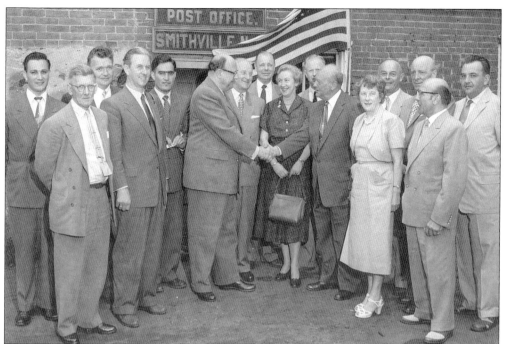

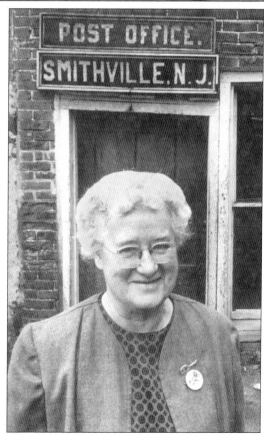

Above, H.B. Smith Machine Company employees and representatives from the US Post Office Department meet outside the Smithville Post Office in 1956. After the general store burned down in the early 1930s, the post office was moved near the H.B Smith Machine Company factory office. Shaking hands at right is Dan Malone, president of the H.B. Smith Machine Company. At right, Postmistress Edith Vaughn stands in front of the Smithville Post Office on her last day of work in 1963. The post office opened in 1866, but service was discontinued on June 5, 1964, and moved to Mount Holly. (Both, courtesy of the Burlington County Board of Chosen Freeholders/Division of Parks.)

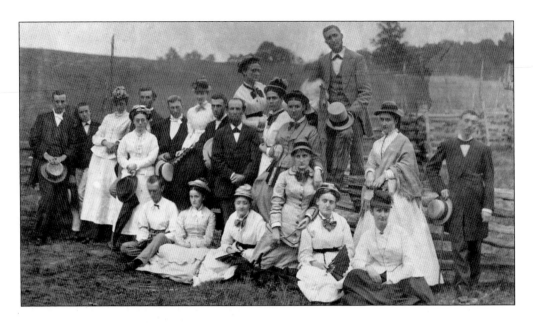

The photograph above, from a picnic held at Smithville during the summer of 1876, includes, from left to right, (seated) Dr. Joseph Wills, Sue Lippincott, Sarah Wills (Evans), cousin Rachel Williams, Rachel Wills, and Hannah Wills (Scattergood); (standing) unidentified, Clayton Wistar, unidentified, Lizzie Butcher, unidentified, Albert Wills, Annie Price, Howard Taylor, Joseph H. Haines, Anna W. Haines, Amie Taylor, Rebecca Wills, and Joshua Wills holding baby Katherine. Standing at right are Emily Gardiner and Joseph Butcher. Below, a stereoscope image shows Elizabeth N. Butcher sitting in the garden of the J.H. Wills farmhouse across from the Smithville Mansion with her dogs Tasso and Ring. (Both, courtesy of the Friends of the Mansion at Smithville.)

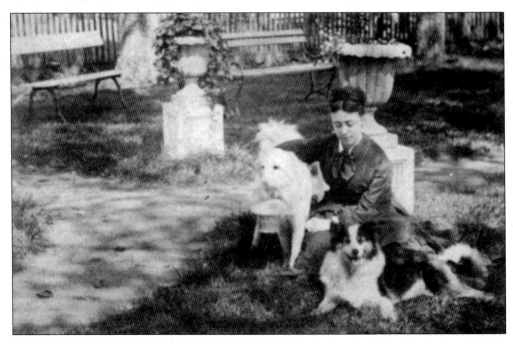

At right, three young girls—from left to right, Christine Hatcher, Anna Albright, and Margaret Walthers—sit on a sled in front of 7 Park Avenue in Smithville during the winter of 1920. The hill near the gazebo in front of the frame worker's houses was an ideal location for sledding. Below, a well-dressed group of friends gather on the road leading to Rancocas Creek beside the Mechanics House. One of the frame worker's houses is in the background. (Both, courtesy of the Burlington County Board of Chosen Freeholders/Division of Parks.)

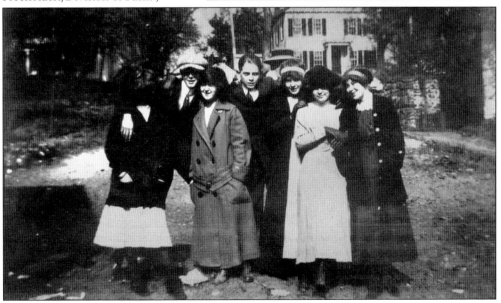

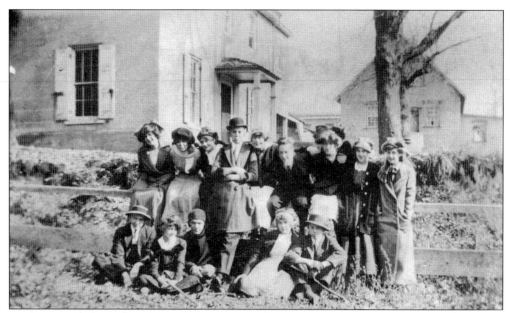

Students pose on Smithville Road beside the Wills farmhouse, at left, around 1913, with their teacher at the center. The two-story, three-bay brick farmhouse, built around 1750 by Ezekiel Wright, is the oldest building in Eastampton Township. (Courtesy of the Burlington County Board of Chosen Freeholders/Division of Parks.)

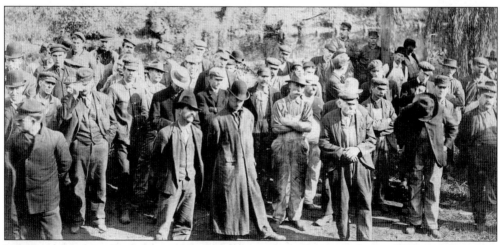

H.B. Smith Machine Company employees gather outside the factory in the late 1890s near Rancocas Creek to listen to a political speech. Every man wears a hat, and their clothing is made of wool, heavy cotton, or corduroy. Men often wore jackets that were durable, dark, and loose. (Courtesy of the Friends of the Mansion at Smithville.)

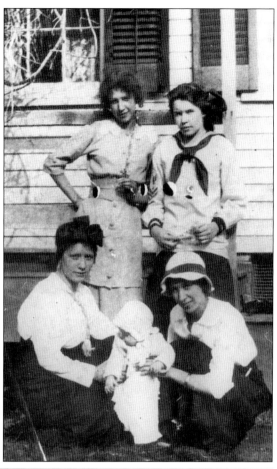

At right, a group of women pose for a photograph with a young child outside a frame house in Smithville. Very few women were employed at the factory except as office workers. A few domestic servants were employed in the Smith mansion. Children were not employed by the H.B. Smith Machine Company. Apprenticeships as machinists, molders, and other occupations in the factory did not begin until boys were 15 or 16 years old. According to the 1870 census, 222 people were living in Smithville, with 140 workers employed in the factory, 81 of whom lived in Smithville. (Right, courtesy of the Burlington County Board of Chosen Freeholders/Division of Parks; below, courtesy of the Friends of the Mansion at Smithville.)

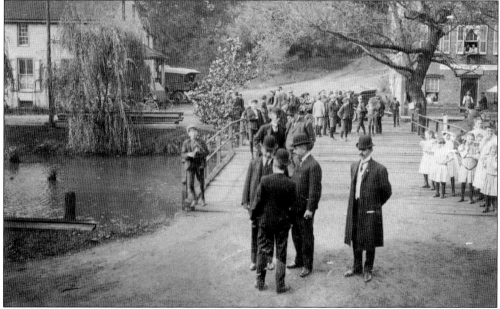

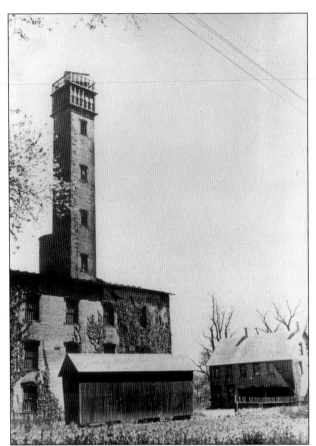

In 1878, the 300-acre Smith farm included a 120-foot brick observation tower located across the street from the mansion. It was said in the press that with all the land that Smith owned, he was "a master of all he surveys" when standing atop the tower. (Photograph by William Augustine, courtesy of the Burlington County Board of Chosen Freeholders/ Division of Parks.)

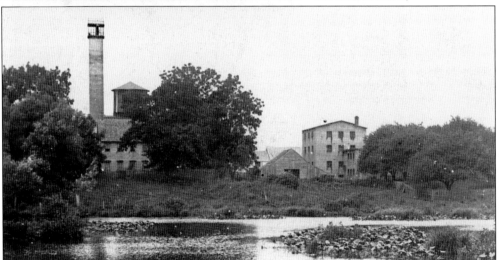

Looking north across Rancocas Creek in 1906, this view shows the farm complex with the observation tower, water tower, the wagon house with an attached dwelling, the granary, a corncrib, and many small outbuildings. The farm buildings were constructed of brick. Iron posts were used to support the roofs, which were made of three-foot-wide cast-iron plates. (Courtesy of the Friends of the Mansion at Smithville.)

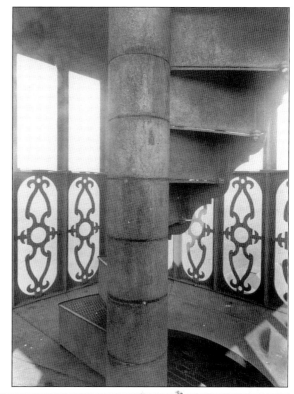

The observation tower had 150 cast-iron steps, which led to an observation deck where H.B. Smith could view his home, factory, village, and farm; on a clear day, he could see Philadelphia. The stairway led to a sub-deck and top deck, both with ornamental railings. Below, Justin Allen Pie, great-grandson of H.B. Smith, pokes his head out of the sub-deck of the observation tower. (Right, courtesy of the Burlington County Board of Chosen Freeholders/Division of Parks; below, courtesy of James Denworth.)

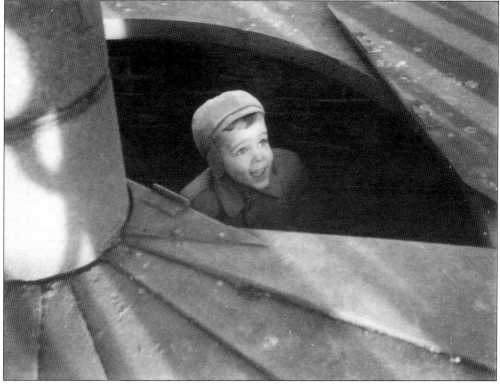

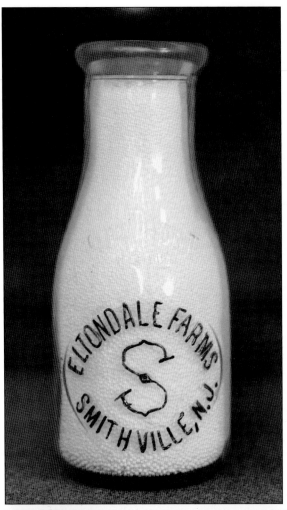

Both Hezekiah Smith and his son Elton made sure that dairy products were available for the workers and their families at Smithville. Hezekiah began his farm operation with 300 acres and later expanded to 450 acres; when Elton arrived, he bought additional land for farming. Elton greatly increased the dairy operation, and the Eltondale Farms milk bottle was used during his ownership of the property. The 1979 view of the entrance to the farm property below shows the mansion in the background. (Left, courtesy of the Friends of the Mansion at Smithville; below, photograph by Thomas Barnett, courtesy of the Burlington County Board of Chosen Freeholders/Division of Parks.)

Hezekiah Smith made the availability of fresh produce, meat, and dairy products for his employees one of his priorities. In the 1870s, he owned one of the largest farms in Burlington County. The large, 400-foot frame dairy barn is one of the few wooden structures that remain on the property. The map below drawn by William Bolger shows the size of the farming operation. (Right, photograph by Thomas Barnett; both, courtesy of the Burlington County Board of Chosen Freeholders/ Division of Parks.)

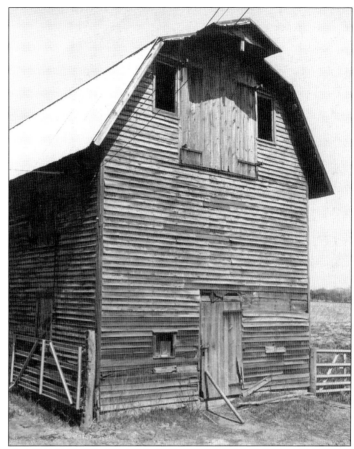

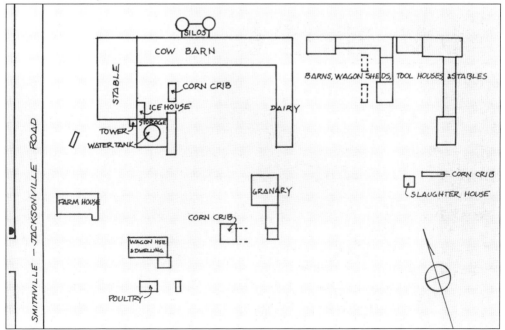

In 1877, a reporter for *True American* magazine stated that "Mr. Smith owns a farm of about 450 acres, most of which is highly cultivated, and employs six farmers, each occupying a separate house." Part of the farm fields, seen at left with the mansion in the background, were still being used in the 1950s. The ornate twin silos built outside the cow barn included an entrance to the barn between them. (Both, courtesy of the Burlington County Board of Chosen Freeholders/Division of Parks.)

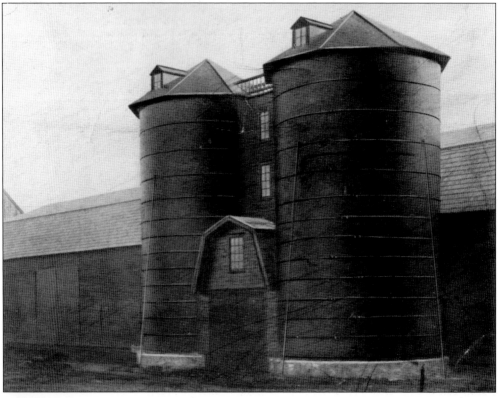

Three
H.B. Smith Machine Company

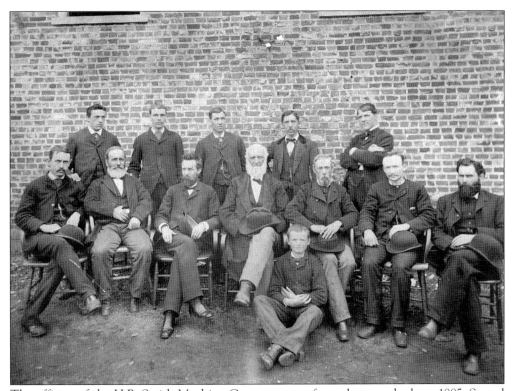

The officers of the H.B. Smith Machine Company pose for a photograph about 1885. Seated at center is Hezekiah B. Smith. Seated third from left is William Kelley, vice president. Seated second from left is Joseph Josiah White, general manager. Seated at far right is Bradford Storey, head mechanic. Sitting on the ground is bicyclist Thomas "The Kid" Finley. (Courtesy of the Burlington County Board of Chosen Freeholders/Division of Parks.)

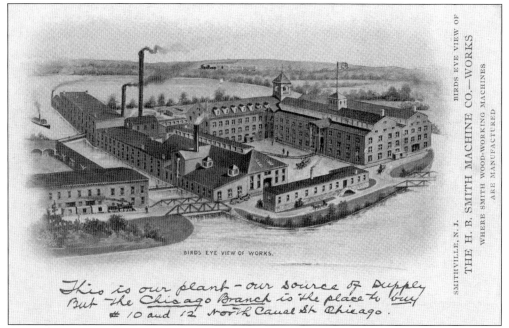

A company postcard titled "Birds Eye View of Works" shows the H.B. Smith Machine Company factory. The card is postmarked July 1906 and was sent out of the Chicago office with a note stating where to buy the machinery in Chicago. (Author's collection)

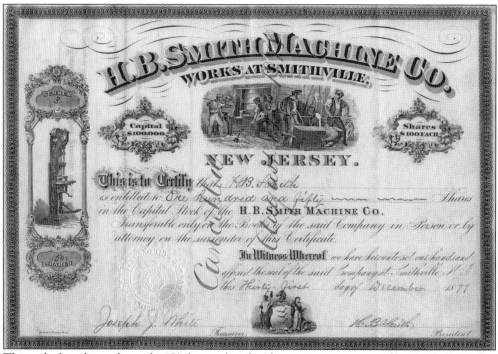

This cashed stock certificate, for 150 shares of stock in his company, was owned by Hezekiah Bradley Smith. Each share was worth $100, totaling $15,000. The company was incorporated on November 30, 1877. (Courtesy of the Burlington County Board of Chosen Freeholders/Division of Parks.)

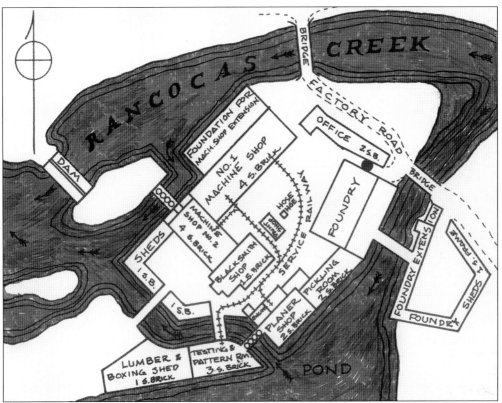

This William Bolger map shows the H.B. Smith Machine Company factory in 1904, with all the buildings including the service railroad inside the factory quadrangle. The island factory is surrounded by Rancocas Creek, the millpond, and spillways. Water was the source of power when the factory opened. (Courtesy of the Burlington County Board of Chosen Freeholders/ Division of Parks.)

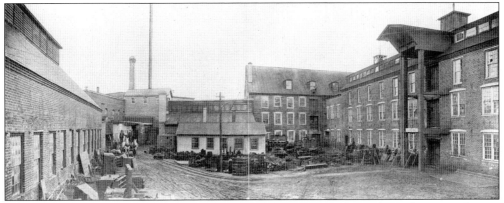

This panoramic photograph shows the inside of the H.B. Smith Machine Company factory quadrangle in the early 1900s. The foundry is to the left, and machine shops 1 and 2 are at right. A team of horses with three workmen are bringing in raw materials to the shops. (Courtesy of the Burlington County Board of Chosen Freeholders/Division of Parks.)

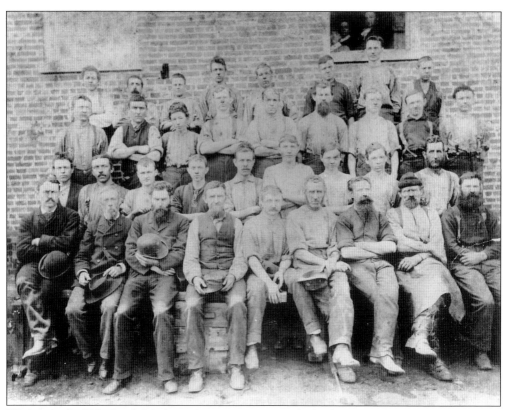

Workers at the H.B. Smith Machine Company pose outside the factory in the mid-1880s. Included in the photograph are some company executives, including Bradford Storey, third from left in the first row, along with two other executives on his right. The advertisement below placed in the *Mount Holly Herald* about the same time seeks a "First-class Machinist and Draughtsman" and "Fifty good, sober, and reliable men" to work in the machine shop. Some 220 workers were employed in the factory, with a little more than half living in the village of Smithville. (Both, courtesy of the Burlington County Board of Chosen Freeholders/Division of Parks.)

WANTED.

A First-class Machinist and Draughtsman, competent to take charge of the mechanical branch of a large establishment for manufacturing Wood-working Machinery.

A liberal salary will be paid. Best of references required as to ability and character.

Address, H. B. SMITH,
 SMITHVILLE, BURLINGTON Co., N. J.

Also, Fifty good, sober, and reliable men to work in Machine shop. References required.

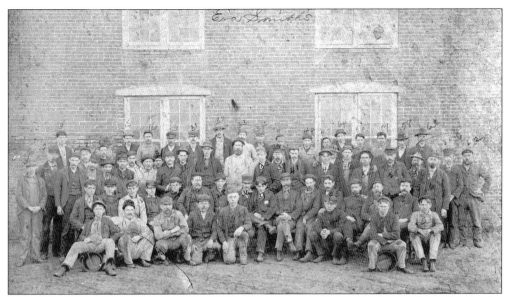

H.B. Smith Machine Company workers pose for a photograph outside the machine shop in the early 1900s. Some of the last names of those pictured include Asay, Atkinson, Bonn, Corson, Emmons, Giberson, Hart, Jennings, Klausen, and McCollough. In 1880, the factory employed machinists, machine shop workers, molders, blacksmiths, foundry workers, and others. (Courtesy of the Friends of the Mansion at Smithville.)

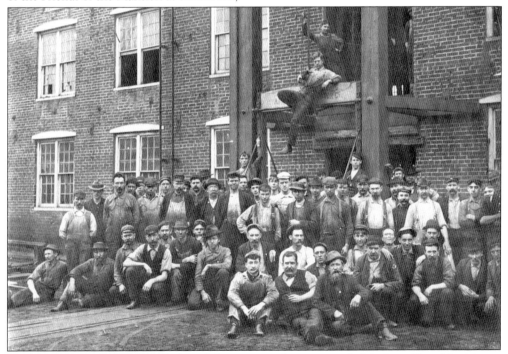

Workers pose on the loading dock and the exterior elevator outside Machine Shop No. 1 in an undated photograph. The number of workers at the factory ranged from 125 when work was slow to 230 when busy. The average pay for a 10-hour day was $2, with a six-day workweek. (Courtesy of the Burlington County Board of Chosen Freeholders/Division of Parks.)

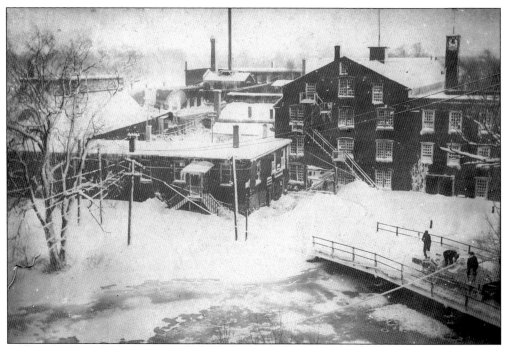

In 1914, workers shovel snow from a wagon onto the frozen Rancocas Creek after a snowstorm. Taken from the fourth floor of the Mechanics House, this unique view photographed by N.E. Lewis shows the H.B. Smith Machine Company factory in the background. (Courtesy of the Burlington County Board of Chosen Freeholders/Division of Parks.)

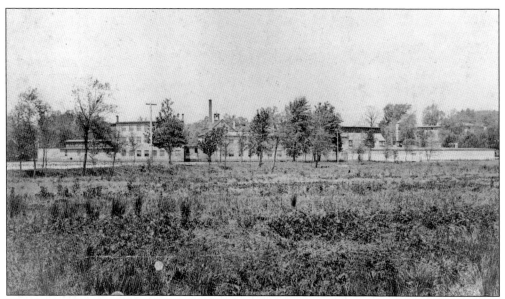

This panoramic view of the H.B. Smith Machine Company seen from across the millpond shows the lumber and boxing buildings, a shed, the testing and pattern room, the planer shop, pickling room, the foundry, and foundry sheds. Near the center, to the right of a smokestack, is the bell tower. (Courtesy of the Burlington County Board of Chosen Freeholders/Division of Parks.)

This bell, made by the Clinton H. Meneely Bell Company of Troy, New York, in 1886, was removed from the H.B. Smith Machine Company bell tower in 1948 by Adolph H. Maxvitat of Stratford, New Jersey. It currently sits outside the Eastampton Township Volunteer Fire Company on Smithville Road. The bell rang at 6:45 a.m. each workday morning, and the men were at their factory stations by 7:00 a.m. In the photograph below are Machine Shop No. 1 and the Machine Shop Extension foundation. The building at right is Machine Shop No. 2, which contained the bell tower. (Right, author's collection; below, courtesy of the Friends of the Mansion at Smithville.)

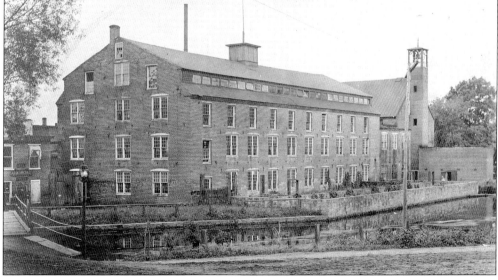

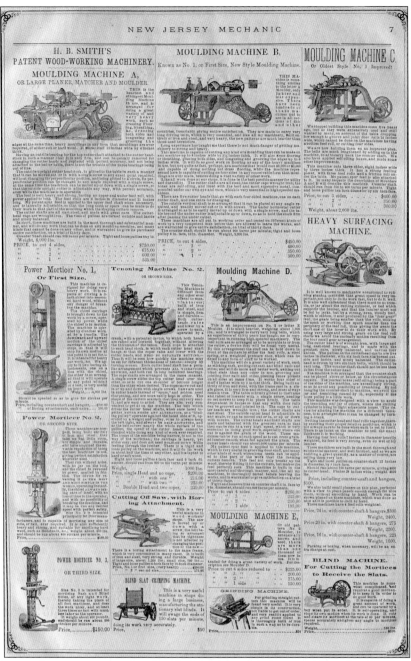

This full-page advertisement was placed in the *New Jersey Mechanic* on Thursday, October 30, 1873. The ad shows the blind machine, for manufacturing window blinds, the first machine patented by Smith in 1849. Other iron woodworking machines included are power morticers (three versions), moulding machines (five versions), a grinding machine, a heavy surfacing machine, a blind slat crimping machine, a cutting off machine, and a tenoning machine. The newspaper publisher was H.B. Smith, and the editor was A.M. Smith. The *Mechanic* may have been the first company newspaper published in the United States. (Courtesy of the Burlington County Board of Chosen Freeholders/Division of Parks.)

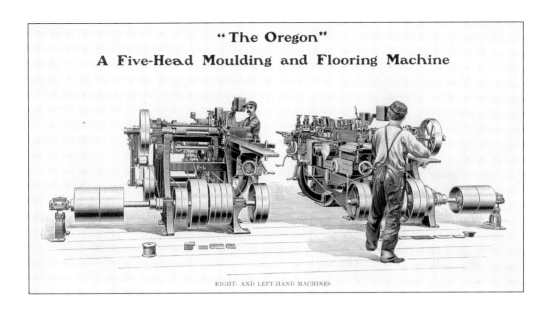

"The Oregon"
A Five-Head Moulding and Flooring Machine

RIGHT- AND LEFT-HAND MACHINES

Shown in these illustrations from the 1902 H.B. Smith Machine Company catalog are left-handed and right-handed five-head moulding and flooring woodworking machines made to order. The above illustration shows "machines . . . designed to meet the wants of the proprietors of a large mill on the Pacific Coast, who desired to make the highest grade of hardwood flooring, in large quantities and at the lowest possible cost." Below is a machine for the manufacture of wooden washboards. Both were very specialized, and it is unknown how many of either of these were ever made. (Both, courtesy of the Burlington County Board of Chosen Freeholders/Division of Parks.)

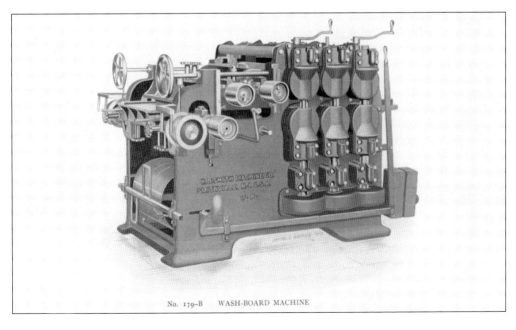

No. 179-B WASH-BOARD MACHINE

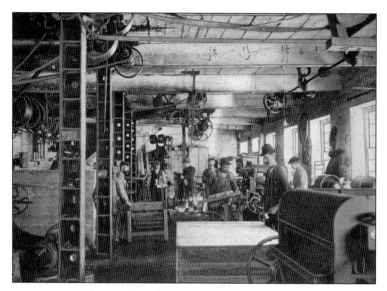

From the *New Jersey Mechanic* newspaper, this is one of the earliest photographs taken inside the testing room of the H.B. Smith Machine Company factory. Unfortunately, no photographs from the 1800s of the inside of the plant exist. (Courtesy of the Burlington County Board of Chosen Freeholders/Division of Parks.)

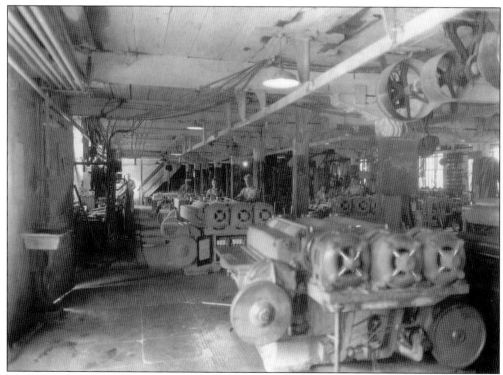

This view of the assembly floor of the H.B. Smith Machine Company shows rows of drum sanders. These machines kept the company in business for many years in the early 1900s. Twenty five of these drum sanders were in operation at the Victor Machine Company plant in Camden, New Jersey. They were used in making the company's phonograph cabinets. (Courtesy of the Burlington County Board of Chosen Freeholders/Division of Parks.)

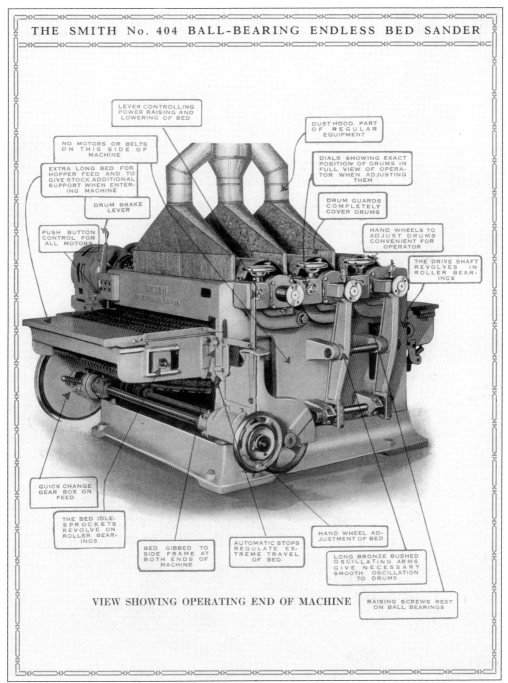

This page from a 1930s sales catalog advertises the Smith No. 404 Ball Bearing Endless Bed Sander. When this sander appeared in the catalog, the H.B. Smith Machine Company had been manufacturing bed sanders for more than 30 years. Credit for the invention of the endless bed sander at Smithville goes to James Lyman Perry, who arrived in 1898. (Courtesy of the Burlington County Board of Chosen Freeholders/Division of Parks.)

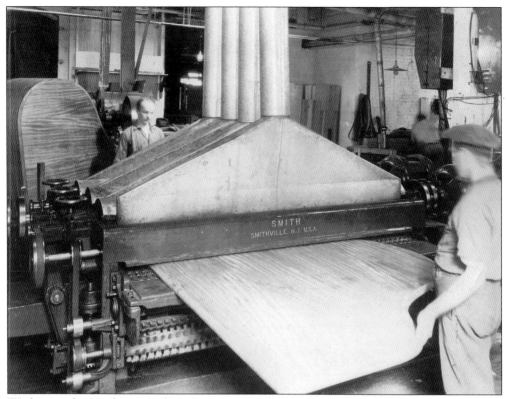

Workers at the Hardman, Peck & Company factory in New York City run a grand piano top through a Smith Machine Company Bed Sander. The company was established in 1842 by Hugh Hardman, who later partnered with his brother John and Leopold Peck. Hardman, Peck & Company pianos were known for their artistry and durability and became the official piano of the Metropolitan Opera Company of New York. (Courtesy of the Burlington County Board of Chosen Freeholders/Division of Parks.)

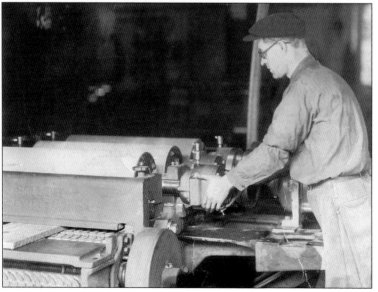

A worker demonstrates an easy method of removing the drum bearing housing from a sander built by the H.B. Smith Machine Company. Many of these drum sanders weighed over seven tons, and it took two men a full day to replace the bed rubbers. (Courtesy of the Burlington County Board of Chosen Freeholders/ Division of Parks.)

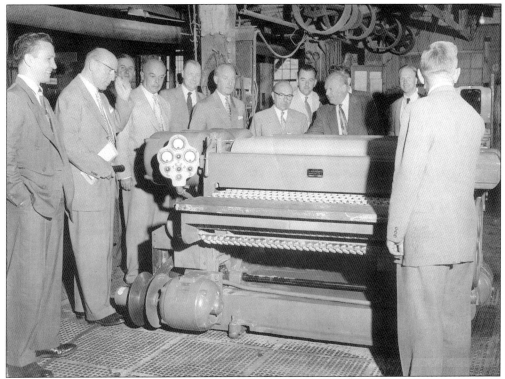

H.B. Smith Machine Company employees and supervisors look over a plywood drum sander inside the factory in the summer of 1956. Joseph Capitanio, chief engineer at H.B. Smith Machine Company, is at left, and Dan Malone, president of the H.B. Smith Machine Company, is third from right. (Courtesy of the Burlington County Board of Chosen Freeholders/Division of Parks.)

Workers Bernie Clapper and Fred Worrell load a drum sander onto the back of a flatbed trailer at the H.B. Smith Machine Company in the 1950s. The seven-ton drum sanders had recently been redesigned for the plywood industry. (Courtesy of the Burlington County Board of Chosen Freeholders/ Division of Parks.)

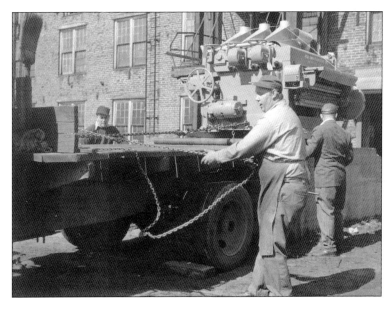

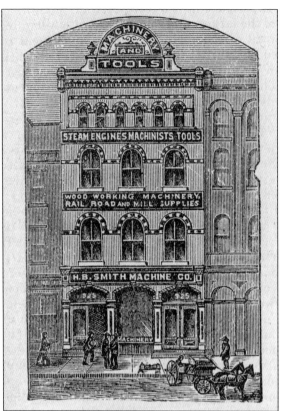

The Philadelphia office of the H.B. Smith Machine Company was at 925 Market Street. It was managed by Joseph J. White, who became one of the top company executives when the firm was incorporated. He also held seven patents on numerous machines, including a chain-making machine and a belt-shifting pulley. (Courtesy of the Library Company of Philadelphia.)

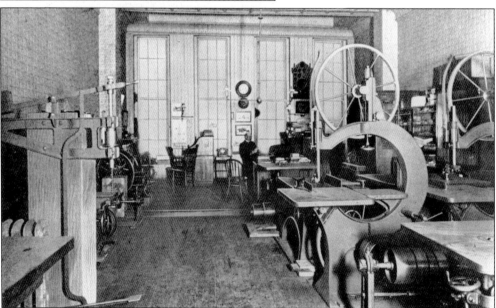

This is an interior view of the New York City branch office of the H.B. Smith Machine Company, located at 121 Liberty Street. The office displayed numerous woodworking machines inside. Hezekiah Smith and other executives often made trips to the New York office to meet with clients. (Courtesy of the Burlington County Board of Chosen Freeholders/Division of Parks.)

Hezekiah B. Smith (center right) stands outside the H.B Smith Machine Company office in Nashville, Tennessee. The company had numerous offices throughout the United States, including Chicago, New York, and Philadelphia. It also had representatives in several European countries. (Courtesy of the Burlington County Board of Chosen Freeholders/Division of Parks.)

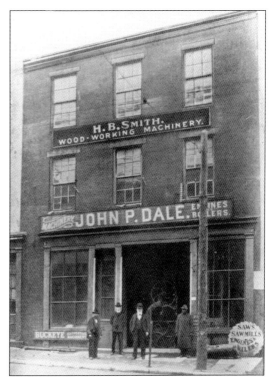

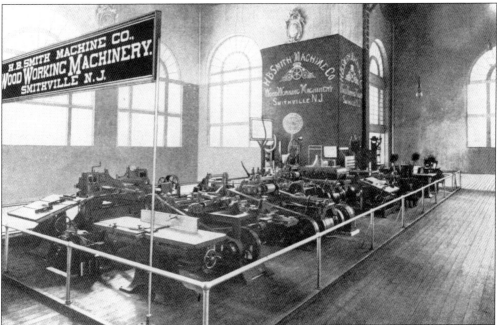

The H.B. Smith Machine Company exhibited at various world's fairs and expositions in the late 1800s and early 1900s, including the Centennial Exhibition held in Philadelphia in 1876. This display was at the Machinery and Transportation Building at the Pan-American Exposition in Buffalo, New York, in 1901. (Courtesy of the Burlington County Board of Chosen Freeholders/Division of Parks.)

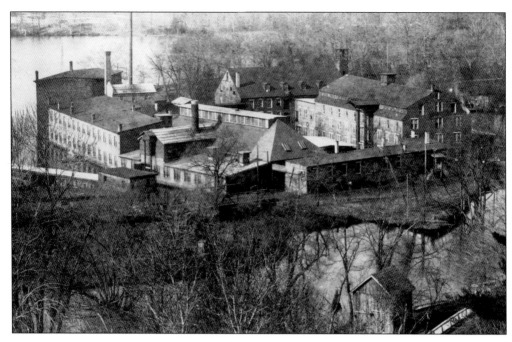

Two views of the H.B. Smith Machine Company factory are shown here, both from the observation tower. The above photograph was taken in the early 1900s when the company, under the direction of Elton Smith, was again at peak production after the H.B. Smith era. Less than 50 years later, the image below from the late 1940s shows a factory in decline, with several buildings demolished. The number of employees dropped to less than 50 during the 1930s and 1940s. (Above, courtesy of the Burlington County Board of Chosen Freeholders/Division of Parks; below, photograph by Don Wentzel, author's collection.)

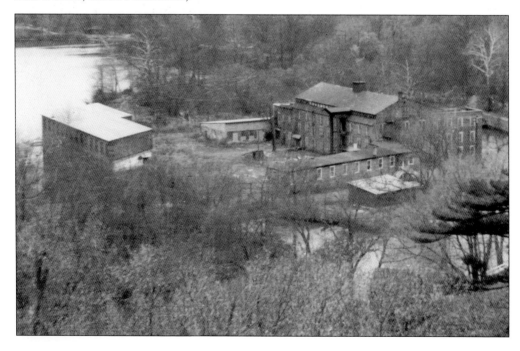

Four

THE AMERICAN STAR BICYCLE

Two American Star bicycle riders pedal past the gated Smithville Mansion's front entrance. Standing in the background are Hezekiah B. Smith (right) and his gardener Fritzy Gzell. The H.B. Smith Machine Company entered into an agreement with George Washington Pressey of Hammonton, New Jersey, to produce the American Star bicycle in 1881. (Courtesy of the Friends of the Mansion at Smithville.)

On October 16, 1880, the *South Jersey Republican* newspaper advertised the first race between an American Star bicycle and a Columbia bicycle at the Hammonton Fair on Wednesday, October 20. The paper also ran an article about the American Star with an illustration of the bicycle that was much improved from Pressey's original patents. The advertisement notes that the Star claimed 14 patented improvements over the Columbia. In the three heats that were run between the Star and the Columbia, the Star won all three. The American Star bicycle and the Columbia bicycle would meet again in much bigger races throughout the country. (Both, courtesy of the Atlantic County Library System.)

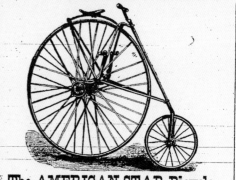

In 1880, inventor George Washington Pressey patented two designs for a velocipede (No. 233,640 and No. 234,722) with the US Patent Office. He was directly competing with the Pope Manufacturing Company, makers of the Columbia high wheel bicycle, the most popular bicycle of the time. Col. Albert A. Pope and his company controlled most of the patents for bicycles. Pressey's velocipede patents skirted Pope's patents by moving the small steering wheel to the front for stability and using a treadle and ratchet system instead of pedals to move the bicycle. The naming of the American Star bicycle came from the double star pattern in the spokes. (Right, courtesy of Hammonton Historical Society; below, courtesy of the United States Patent and Trademark Office.)

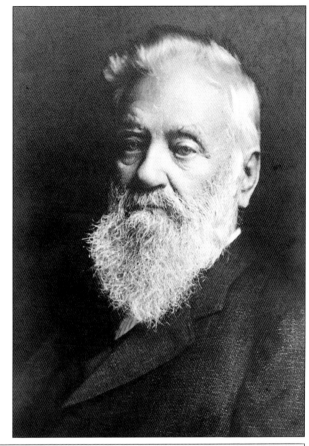

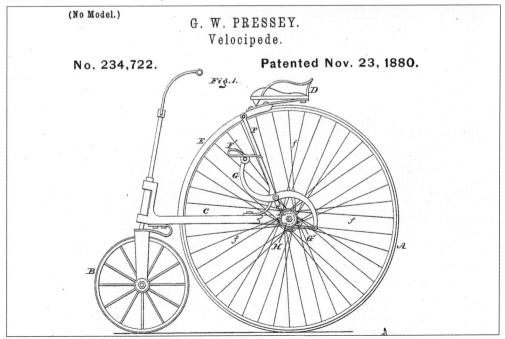

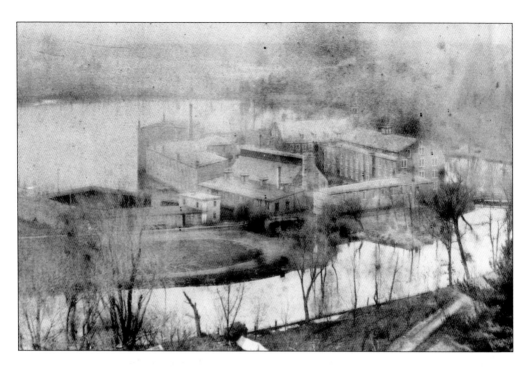

The H.B. Smith Machine Company built an eleventh-of-a-mile oval track outside the factory to test its American Star bicycles and make improvements. The above photograph from the 1880s shows the velodrome with steeply banked curves and a railing. The track was located between the factory buildings and the Rancocas Creek. The idealized illustration below, from an 1889 company letterhead, shows the test track in use. Fifty percent discounts were given to employees to purchase Star bicycles. Many employees and executives became accomplished riders and competitors on the Star. (Both, courtesy of the Burlington County Board of Chosen Freeholders/Division of Parks.)

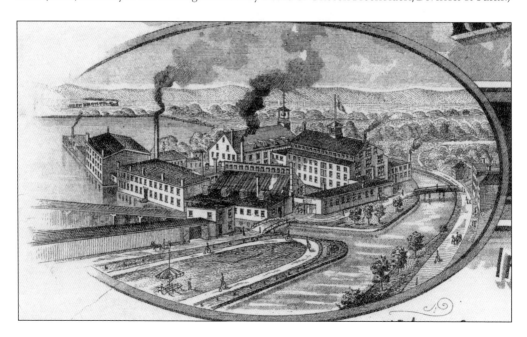

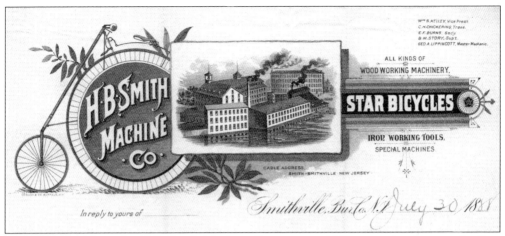

This letterhead from the H.B. Smith Machine Company in 1888 primarily promotes the Star bicycle, with the machinery and tools featured much less prominently. The Star was a great marketing device for Smith's company. The letter to the editor below from the May 23, 1884, issue of *Bicycling World* magazine signed by the H.B. Smith Machine Company presents the company's position regarding a previous article on the firm's ability to meet the demand for the American Star bicycle. The letter states that the company had bicycles on hand and was making improvements at its factory to accommodate the demand for the product. (Above, courtesy of the Burlington County Board of Chosen Freeholders/Division of Parks; below, author's collection.)

CORRESPONDENCE

[*This department is open to communications relating to bicycling; the editor disclaiming all responsibility for opinions expressed, and reserving the right to reject such, or such portions, as in his judgment are improper by reason of gratuitous advertising or objectionable phraseology.*]

H. B. Smith Machine Co.

Editor Bicycling World: — Referring to some items in your issue of 9 May, relating to the Star and its manufacturers, beg to say that on the first of the year we had on hand Star bicycles finished and in process of manufacture, which represented in actual cost to us considerably over $10,000, and we have constantly increased our facilities ever since, and we expect to be able to fill all orders with reasonable promptness. We admit that the demand for the machine rather exceeds our most sanguine expectations, but we shall use every possible effort to meet the demand.

H. B. SMITH MACHINE COMPANY.

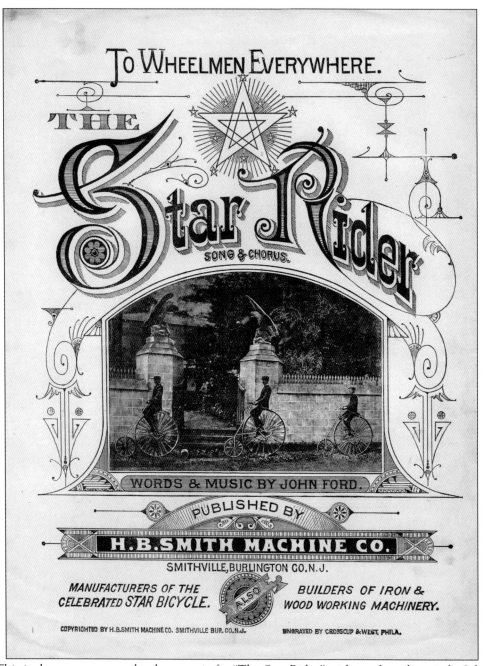

This is the cover page to the sheet music for "The Star Rider," with words and music by John Ford. The song was commissioned by the H.B. Smith Machine Company and published in 1883. It was not unusual for companies to hire composers to plug their products. Prior to the invention of the radio and television, families gathered around the pianos in their houses and entertained each other. The sheet music business was a big enterprise. Quite often, this type of advertising sheet music was given away free to promote a product or service. The most popular song to come out of the bicycle craze was "Daisy Bell," also known as "A Bicycle Built for Two," composed by Harry Dacre in 1892. (Courtesy of Sandy Marrone.)

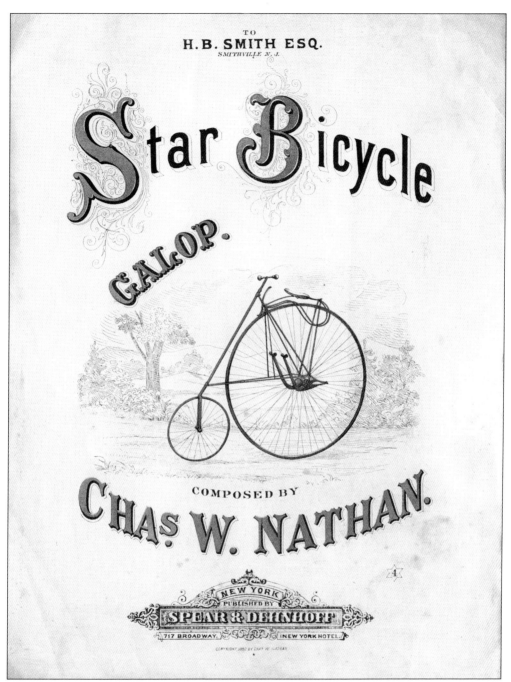

This is the cover page for "The Star Bicycle Galop," composed by Charles W. Nathan. It was published by Spear & Dehnhoff of New York in 1882. Bicycle-themed sheet music was another marketing scheme to promote bicycle riding. The galop was a popular social dance in the late 19th century and was a forerunner of the polka. Over 400 songs on the subject of bicycles were written in the 1800s. The bicycle had a huge impact on transportation and popular culture, and the high-wheel bicycle was in the forefront of the trend. (Author's collection.)

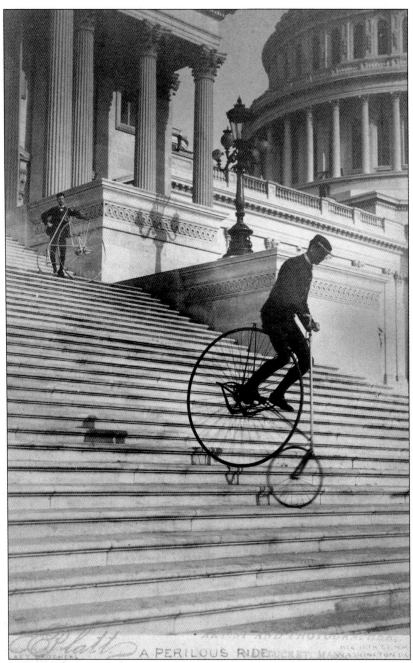

The most famous Star bicycle photograph was taken in Washington, DC, and shows William Robertson of the Capital Bicycle Club riding a Star down the steps of the US Capitol building in 1884. In the background is rider Rex Smith with his Star. Many cyclists rode down these steps, including Burt Pressey, the son of the Star inventor. The riders had to sneak onto the Capitol steps in the early morning hours in order to avoid being arrested by the police. It is said that the H.B. Smith Machine Company paid some of these riders to promote the safety aspects of the bicycle. Even the arrests brought attention and free publicity to the American Star. (Courtesy of the Library of Congress.)

The H.B. Smith Machine Company constantly advertised its bicycles in popular cycling and outdoor magazines. This full-page advertisement in the November 1889 *Bicycling World and L.A.W. Bulletin* shows recent victories in races held throughout the United States, in Los Angeles; Ottawa, Kansas; Minneapolis; and Reading, Pennsylvania. (Author's collection.)

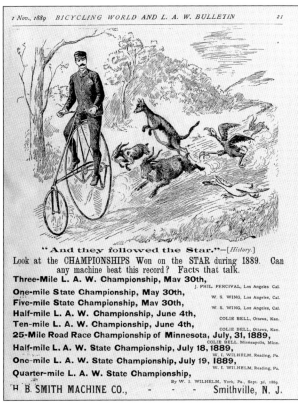

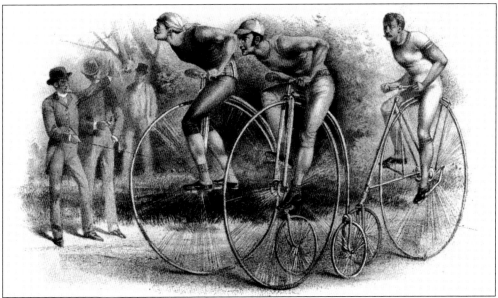

By 1889, the American Star bicycle had become a factor in national cycling competitions and part of the American culture. Here, a cigar box label from that era shows a race with two high-wheel, ordinary bicycles and an American Star (right). Cigar box labels were used to distinguish one brand from another and promoted sports, entertainment, or news of the day. (Courtesy of David Beach.)

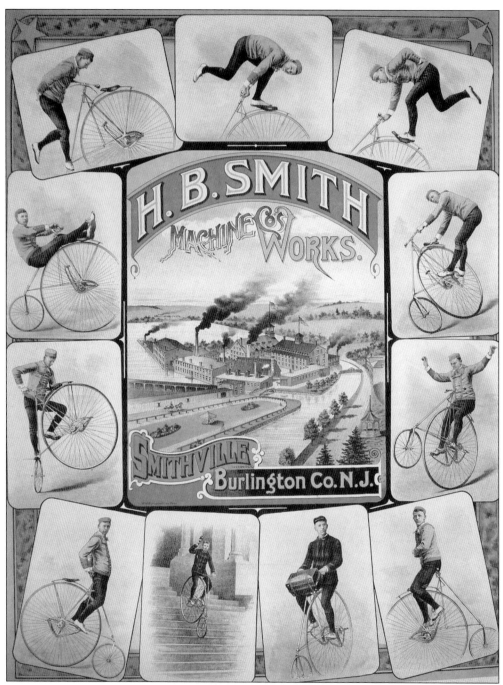

The H.B. Smith Machine Company hired numerous trick cyclists to perform at theaters, meeting halls, and at outdoor events all over the country and in Europe to promote its bicycle. One of the more famous trick Star riders was deaf and mute John Stout of Chicago. The company produced a large, full-color poster with photographs of Stout performing some of his tricks. In the center of the poster was a full-color illustration of the H.B. Smith Machine Company, with the test track in the foreground. (Courtesy of Carey Williams.)

Trick rider John Stout performed various feats on the American Star bicycle, including riding down the steps of the Michigan capitol. He also traveled to England (below) to promote the American Star at bicycle expositions throughout the country. (Right, courtesy of the Burlington County Board of Chosen Freeholders/ Division of Parks; below, courtesy of the Franklin Institute Collection.)

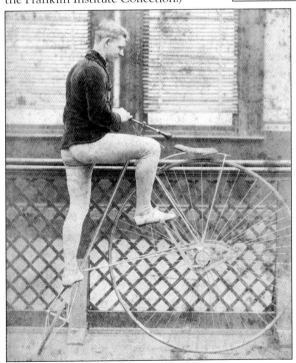

JOHN M. STOUT,
CHAMPION FANCY STAR BICYCLE RIDER OF THE WORLD.

> [9 Oct., 1885.] THE BICYCLING WORLD
>
> **Anybody with a Better Record may copy this Page.**
>
> ---
>
> You Bet Your Life there IS Something in Ours!
>
> # 100 MILES
>
> ## 6 Hours, 57 Minutes.
>
> # 50 MILES
>
> ## 3 Hours, $10\frac{1}{2}$ Minutes.
>
> DONE ON THE MUCH-ABUSED
>
> # STAR BICYCLE,
>
> BY GEO. E. WEBER,
>
> IN THE
>
> **Boston Bicycle Club's Third Annual Race,**
>
> WON FOR THE SECOND TIME.

H.B. Smith Machine Company employees often raced with American Star bicycles. The company offered its employees a 50 percent discount. George Weber began to work for the company in 1884 and started competing at the same time, becoming a sensation on the racing circuit. This advertisement in *The Bicycling World* magazine touted his record-setting achievement in a 100-mile race near Boston when he was only 18 years old. Other employees racing for the company included Charles Frazier, Charles Chickering, Thomas Finley, and Joseph Powell. There was a controversy at the time that these paid employees/racers should be designated as professionals, leading many bicycle meets to have both amateur and professional categories. (Author's collection.)

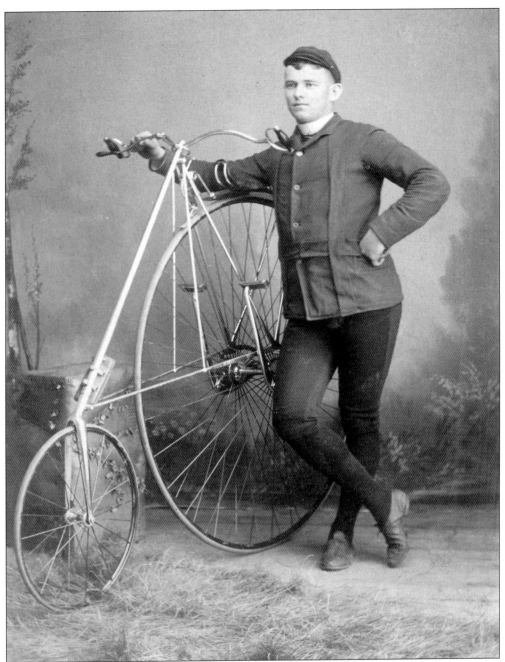

World famous cyclist George Weber poses with his nickel-plated American Star bicycle in a studio photograph. Weber was one of the most famous cyclists in the world in 1885 and 1886. On August 24, 1886, at the age of 21, his illustrious career was cut short when he died of typhoid fever. An article in the August 27, 1886, issue of *Bicycling World* notes that "in his year and a half racing he has taken thirty-six prizes in forty races. He was the first American to cover twenty miles inside of the hour." An 1885 *Burlington City Directory* lists his occupation as "bicyclist." He was probably one of the few people in the United States who could claim that job description. (Courtesy of the Burlington County Board of Chosen Freeholders/Division of Parks.)

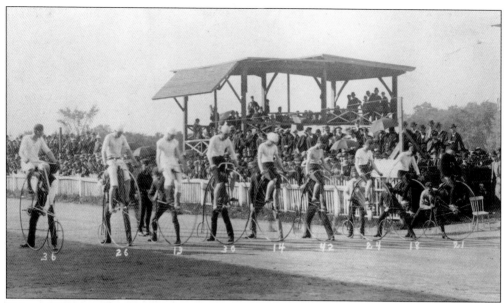

George Weber (left), riding his American Star bicycle, lines up for the start of the League of American Wheelmen's annual three-mile amateur race on the first day of the Springfield (Massachusetts) Bi-Club Tournament on September 8–10, 1885. The three-day Springfield meet was the biggest bicycle race in the country at the time. Weber won the race in 8 minutes and 34.8 seconds. (Courtesy of the Burlington County Board of Chosen Freeholders/Division of Parks.)

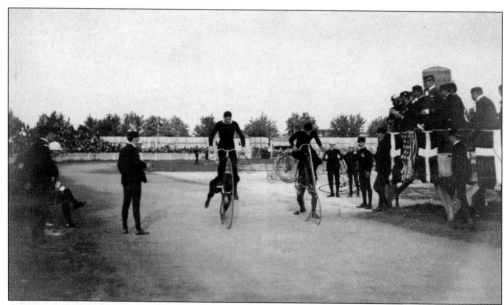

American Star bicycle racer Charles Frazier (left) and George Hendee prepare to start a one-mile race at the League of American Wheelmen championship meet in Washington, DC, on May 23, 1884. Competitions were the main source of advertising for the Star. The H.B. Smith Machine Company awarded a Star bicycle to the winner of the most prestigious race at the meet. Cycling enthusiasts read the bicycling magazines to see who the fastest racers were and what bicycle they rode. (Courtesy of the District of Columbia Public Library Special Collections.)

One of the world's greatest sprint cyclists was Arthur Augustus Zimmerman. Born in Camden, New Jersey, and raised in Freehold, he was nicknamed the "Jersey Skeeter." Zimmerman, seen at right and on the right below, competed on a Star at the first track cycling world championship in Chicago in August 1893. It was the last appearance on the track of the ordinary bicycle and the Star, according to *The Bearings* magazine. Zimmerman won the race and went on to race on a Raleigh bicycle and win more world championships. (Right, courtesy of the Franklin Institute Collection; below, author's collection.)

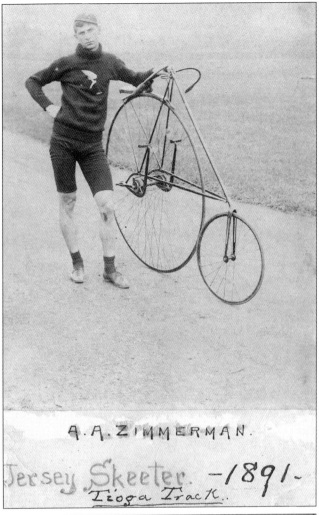

A. A. ZIMMERMAN.
Jersey Skeeter. —1891—
Tioga Track.

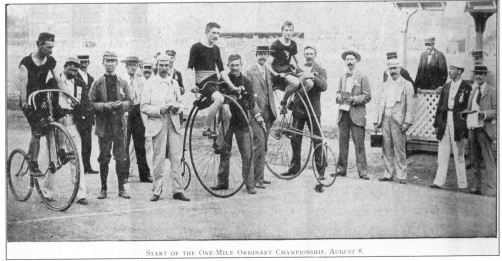

START OF THE ONE-MILE ORDINARY CHAMPIONSHIP, AUGUST 8.

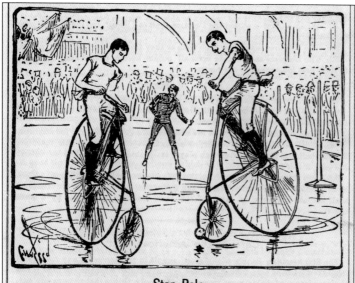

Star Polo.

This interesting game was first suggested by Mr. H. S. Owen of the Capitol Bi Club, Washington, D. C., and to whom the credit is mostly due for bringing it out. The small wheel is used as a mallet to drive the ball and when the players become skilled in the art the game is very interesting and exciting.

Page 23 of the March 1886 American Star bicycle catalog shows two men playing polo using the front wheel of the Star instead of a mallet to drive the ball. The game was another way to promote the Star bicycle. The Star, with its small front wheel, was the only bicycle that could be used to play the sport. (Courtesy of Kim and Wayne Batten.)

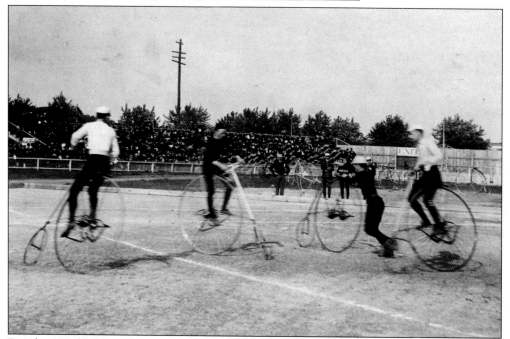

Bicycling World featured an article about this match in the May 30, 1884, issue: "The game of polo, as played by the Washington and Smithville teams, proved an interesting spectacle, and very exciting. It was surprising to witness the command which the riders had over their machines, and the people held their breath when the four would come together with a rush in a struggle for the ball, but the brakes would be applied in time and no collision would occur." (Courtesy of the District of Columbia Public Library Special Collections.)

Herbert S. Owen of the Capital Bicycle Club of Washington, DC, is credited with inventing the game of bicycle polo on the Star. Polo games played on the Star bicycle were a popular indoor and outdoor sport. The players in the photograph below include Rex Smith and Will Robertson of the Capital Bicycle Club and Thomas Finley and Charles Chickering with the Smithville team. The latter two were both employees of the H.B. Smith Machine Company. Chickering would go on to become the company treasurer. (Both, courtesy of the District of Columbia Public Library Special Collections.)

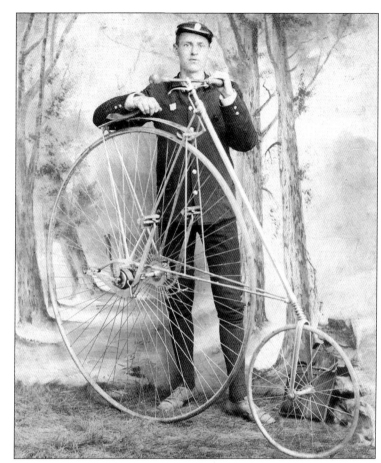

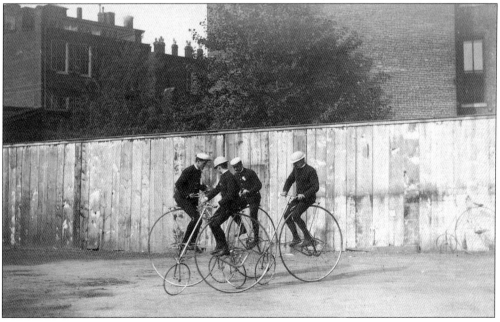

On the Star.

CLICK, click, click, click, the wheel goes round,
We're skimming o'er the frozen ground;
The air blows keen, our fingers smart,
The blood goes bounding through the heart.
The fields are mantled o'er with snow,
The ice king's stopped, the waters flow;
The leafless branches, brown and sere,
Sway sadly on the list'ning ear.
But what care we for frost or snow?
Our pulses throb, our heart's aglow,
Our cheerful voices, loud and free,
Are trolling out the Star man's glee.
Let winter in an icy clasp
The flowing river firmly GRASP,
Or let his winds blow sharp and shrill,
And snow-flakes hide the distant hill;
He cannot make our stout hearts quake,
Nor can from us our pleasure take;
We'll push our wheels through clogging snow,
Or o'er the frozen river go.
No fearful fall o'er handle-bar
Awaits the rider of the Star;
Down hill may freely use the brake,
No fear he will a header take.
Some ridicule the jig-saw motion,
But better that unto our notion,
Then playing leap-frog on the stones,
To bruise the hands or break the bones.
Let each one ride what suits him best,
Time and the roads the surest test;
He laughs the best who laughs the last
And safely rides the perils past,
Where many a crank, with sudden lurch,
Falls headlong from his pig-skin perch.
High speed for safety's well exchanged,
But speed and safety both are claimed
By every rider of the Star.
This home machine no foreigner
From Briton's isle, nor yet from France,
That land of fashion and romance.
No Pope can any royalty claim
On this bicycle's wheel or frame;
'T was thought out 'mid the Jersey sands,
And put in shape by Jersey hands,
And Jersey riders near and far
Extol the working of the Star.
This wheel may *pater familias* ride,
Or octogenarian safe bestride.
Secure, no matter where he roam,
'T will bring him safely to his home;
Then mount, boys, mount, make no delay,
O'er stones or ledges we'll make our way. J. D. D.

This poem titled "On The Star" appeared in the April 27, 1883, issue of *Bicycling World*. Shortly after the Star bicycle was introduced, the manufacturer tried to establish it as one of the best among the high-wheel bicycles of the time. The poem extols the virtues of the bicycle made in the United States by "Jersey hands." The Star was unique in that it was designed and built in the United States, while the competition was designed or built abroad. (Author's collection.)

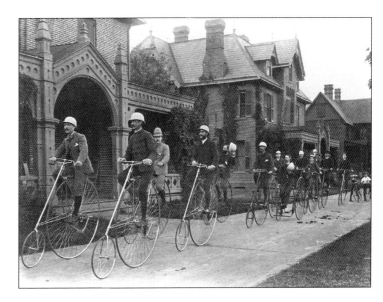

American Star bicycles were very popular in Washington, Philadelphia, and Boston. There was a Star Bicycle Club in Rochester, New Hampshire. In one of the largest gathering of Stars, members of the Kendall Green Bicycle Club of Weston, Massachusetts, parade on the green in 1884. (Courtesy of Richard DeLombard.)

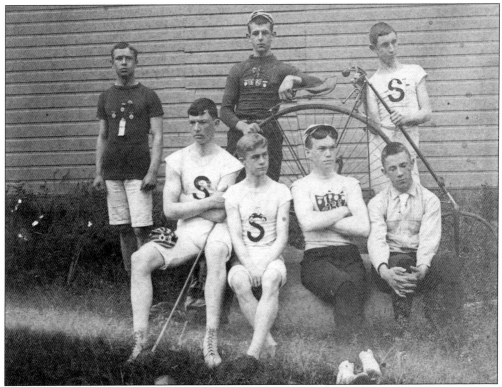

Members of the 1893 Swarthmore College bicycle team pose with a Star bicycle. One of the members of the team is Henry H. Heulings of Moorestown, New Jersey. Cycling competitions were held against other colleges, and bicycle races were also included in college track meets using the same cinder track. Usually, there was a sprint race as well as a longer two-mile race for bicycles included in the track-and-field program. (Courtesy of Kim and Wayne Batten.)

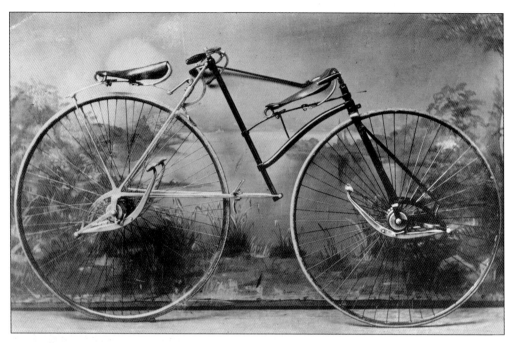

In the late 1880s into the early 1890s, the H.B. Smith Machine Company began to produce different bicycles and tricycles to keep up with the market demand. Included in its production were a tandem bicycle (above), a tricycle (below), a ladies' lever safety bicycle, and a diamond-frame men's lever safety bicycle with pneumatic tires. A lawsuit brought by George Pressey in the late 1880s and the death of Hezekiah Smith in 1887 brought the end of enthusiasm for the bicycle at the company. Production stopped in the early 1890s. (Both, courtesy of the Burlington County Board of Chosen Freeholders/Division of Parks.)

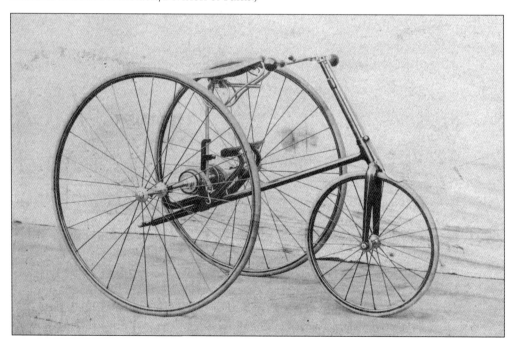

In 1884, Lucius Copeland of Phoenix, Arizona, used an American Star bicycle to construct a new demonstration vehicle with a ¼ horsepower engine. The motorized Star was able to cover a mile in four minutes and could carry enough fuel to operate for an hour. Copeland traveled throughout the country promoting the vehicle. The H.B. Smith Machine Company also designed and built a steam-powered tricycle using kerosene as fuel to produce steam in a copper boiler. The tricycle never got beyond the test stage. (Right, author's collection; below, courtesy of the Burlington County Board of Chosen Freeholders/Division of Parks.)

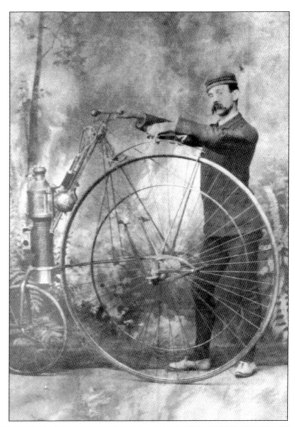

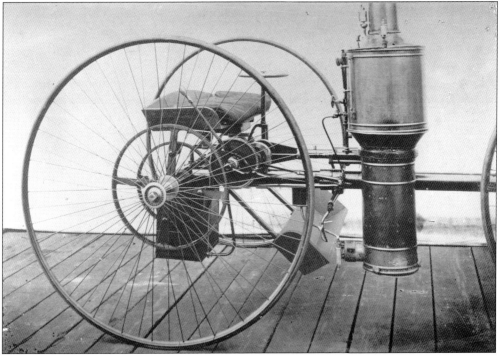

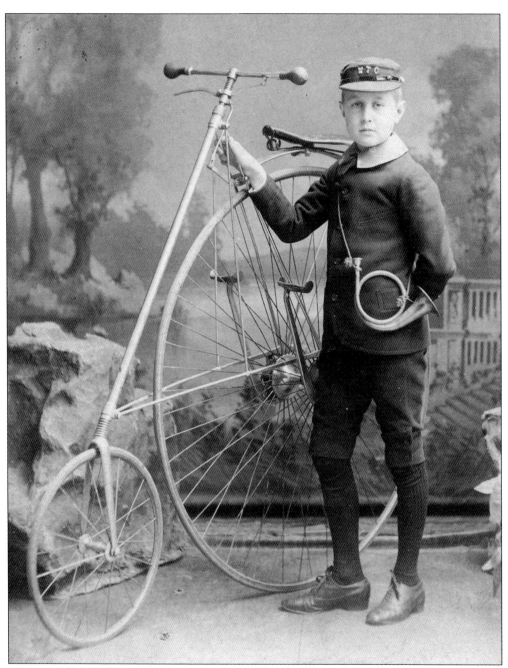

Eleven-year-old Abraham "Jack" Lincoln II was photographed standing beside an American Star bicycle in May 1885. He was the middle child born to Robert Todd Lincoln and Mary Harlen Lincoln and the only grandson of Pres. Abraham Lincoln. An installment of the "Celebrities at Home" series published in *The Republic* on June 18, 1881, features the Robert Lincoln family and notes: "The second [child] is a boy named Abraham, about eight years old, who rides a bicycle like a professional in company with the sons of President Garfield and Attorney General MacVeigh." Unfortunately, Jack Lincoln died on March 5, 1890. (Courtesy of the Allen County Public Library and Indiana State Museum, from the Lincoln Financial Foundation Collection.)

Five
THE MOUNT HOLLY AND SMITHVILLE BICYCLE RAILROAD

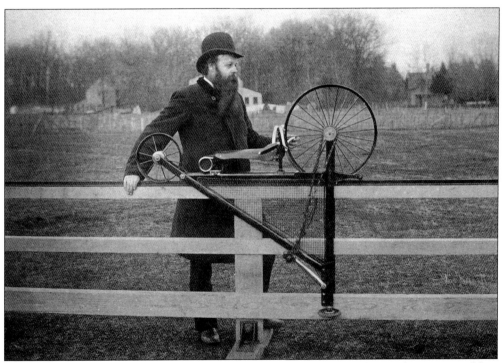

Inventor Arthur Ethelbert Hotchkiss stands beside his bicycle railroad. In early 1890, Hotchkiss approached the H.B. Smith Machine Company with a revolutionary idea to build a self-powered bicycle railway that could transport workers from Mount Holly to Smithville and back again along a fence-like structure. (Courtesy of the Burlington County Board of Chosen Freeholders/ Division of Parks.)

Mount Holly and Smithville Bicycle Railroad inventor Arthur E. Hotchkiss, lower right, supervises workers using large wooden mallets to drive cedar footings into the ground during construction of the 1.8-mile railway. According to the February 6, 1892, *Mount Holly Herald*, it took "1,050 cedar rails for bridging and trestle work, 70,000 feet of lumber, 10,000 feet of steel rails, 3,500 of iron casting, 5,000 bolts and washers, 60 gross tons of screws and 800 pounds of nails and spikes" to build the railroad. It had to be built in an almost straight line from one town to the other while crossing the north branch of Rancocas Creek about 10 times. (Photograph donated by Barbara and Everett Turner, courtesy of the Burlington County Board of Chosen Freeholders/Division of Parks.)

Arthur Hotchkiss (far left) looks over the surveyors and construction workers building the Mount Holly and Smithville Bicycle Railroad in 1891. The railway had little to no elevation change along its route. (Courtesy of the Mount Holly Historical Society.)

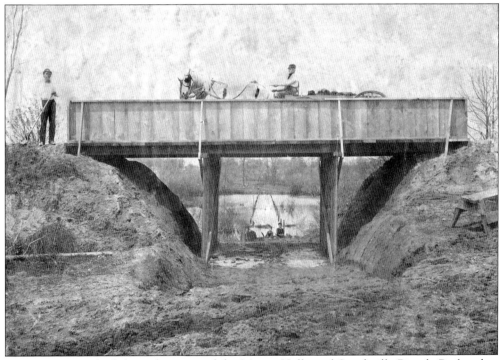
Overpasses were built long the route of the Mount Holly and Smithville Bicycle Railroad so farmers could access their fields. This overpass allowed a businessman access to his ice-cutting operation in the winter. The overpass allowed the bicycle railroad riders to go underneath. A section of Rancocas Creek can be seen in the background, with supports driven into the creek bed for the railway. (Courtesy of Kim and Wayne Batten.)

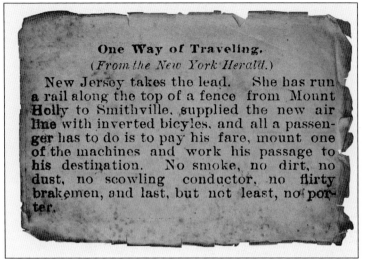

This 1892 article from the *New York Herald* promoting the benefits of the Mount Holly and Smithville Bicycle Railroad that opened to the public that same year was reproduced in the *Mount Holly Herald*. (Courtesy of the Burlington County Board of Chosen Freeholders/Division of Parks taken from the Cowgill Scrapbook.)

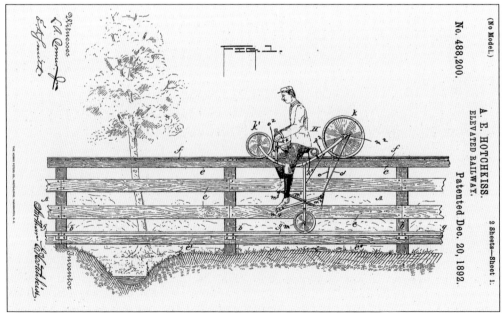

Arthur E. Hotchkiss's patent application (No. 488,200, patented December 20, 1892) for an elevated railway that was to become the Mount Holly and Smithville Bicycle Railway is seen here. The patent drawing shows a man riding along the fence-like structure on a unique bicycle. The final vehicle used on the railroad varied from the patent application, including moving the large wheel to the front of the vehicle. (Courtesy of the United States Patent and Trademark Office.)

MOUNT HOLLY and SMITHVILLE
BICYCLE RAILROAD.

OVER 2,000 PERSONS CARRIED ON IT IN THE LAST 3 DAYS!

TO-DAY, Saturday, September 17/92

And hereafter until further notice, the present POPULAR EXCURSIONS will be continued until 11 P. M., daily, (Sunday excepted). The road will be operated in its most improved manner.

Ample guards have now been provided over the wheels to prevent the throwing of water formed by dew settling on the track in the evening.

A. E. HOTCHKISS,
Vice President and Manager.

A handbill given out during the Great Mount Holly Fair on Saturday, September 17, 1892, promoted the Mount Holly and Smithville Bicycle Railroad. The railroad opening took place on September 13, the second day of the fair, one of the largest in the state of New Jersey. Although the railroad was more than a mile from the fairgrounds, it still attracted more than 2,000 riders in the first few days and 5,000 riders in the first 10 days. The bicycle railroad operated every day and evening except Sunday. The new attraction was almost as popular as the fair, with the price of a round-trip ticket being 10¢. (Courtesy of the Burlington County Board of Chosen Freeholders/Division of Parks, taken from the Cowgill Scrapbook.)

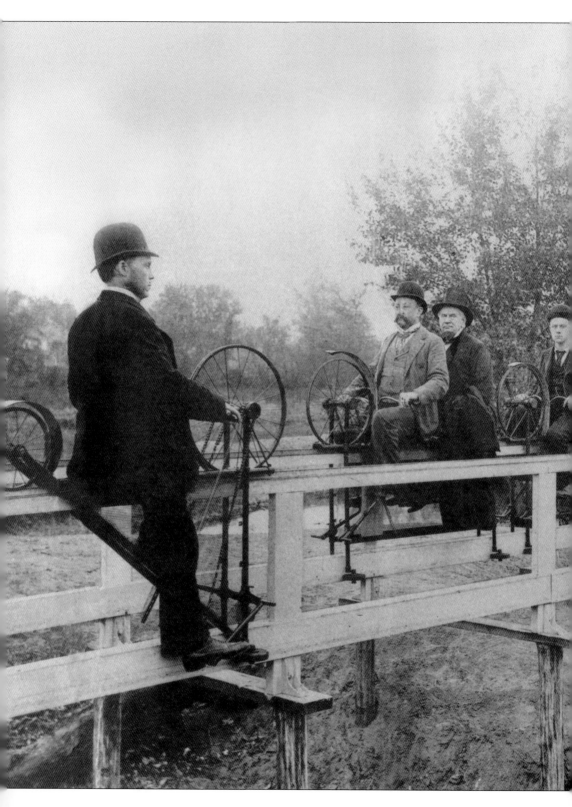

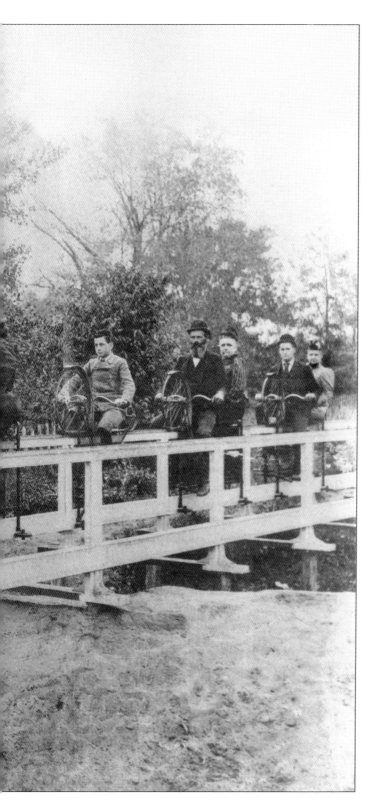

Riders on the Mount Holly and Smithville Bicycle Railroad pedal single and tandem vehicles across Rancocas Creek and open fields on their way to Smithville. The *Mount Holly Herald* reported that these riders were probably shop owners and store workers on their way to work at Smithville's Mechanics House since they were dressed better than factory workers. The image was used in a promotional advertisement in 1893 for the bicycle railroad in magazines across the United States. Arthur Hotchkiss was hoping that the novel rail line would be the next big thing in transportation. (Courtesy of the Burlington County Board of Chosen Freeholders/ Division of Parks.)

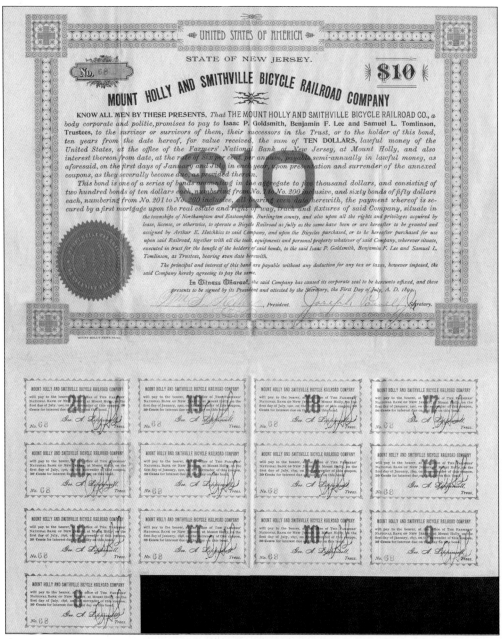

A separate company was incorporated that included members of the H.B. Smith Machine Company and Arthur E. Hotchkiss. The new company offered $10,000 in stock and $5,000 in bonds. Within a month, employees of the H.B. Smith Machine Company had purchased $1,000 worth of the bonds. Shown is a $10 bond certificate (No. 68) issued for the Mount Holly and Smithville Bicycle Railroad, with seven semiannual coupons (good for 30¢ each) redeemed. It is signed by William S. Kelley, president of the company. Five hundred $10 bonds were issued to raise capital to build vehicles, construct a test track, and purchase rights-of-way to build the railroad. (Courtesy of Kim and Wayne Batten.)

This preview article on the Hotchkiss Bicycle Railroad in operation between Mount Holly and Smithville was published in the April 16, 1892, issue of *Scientific American*. The article was reprinted from *Street Railway Review* magazine. The illustration accompanying the article shows Arthur Hotchkiss riding a rail fence bicycle. (Courtesy of *Scientific American*.)

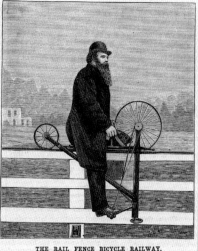

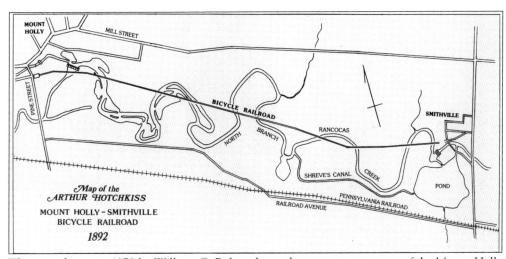

This map drawn in 1979 by William C. Bolger shows the approximate route of the Mount Holly and Smithville Bicycle Railroad. It shows one terminus near Pine Street in Mount Holly and the other near the dam in Smithville, where the H.B. Smith Machine Company was located. The 1.8 mile route could be traveled in about six minutes by a healthy young person. (Courtesy of the Burlington County Board of Chosen Freeholders/Division of Parks.

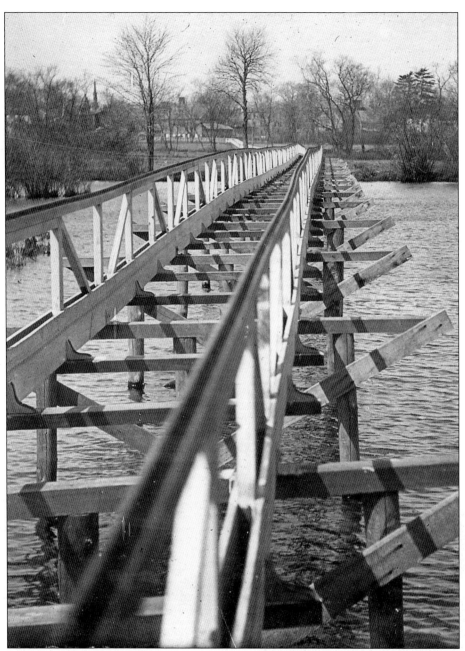

This view of the double-track Mount Holly and Smithville Bicycle Railroad looks back toward Mount Holly across the north branch of Rancocas Creek and Mill Dam. In the background is the Relief Fire Company on Pine Street, where the rail line terminus was located. The location of the terminus was convenient for commuters since it was a short distance from downtown. The cost of a round-trip ticket was 10¢, and a monthly pass was $2. For the factory workers, commuting from Mount Holly to Smithville was not easy. The train did not run frequently enough, and the Smithville train station was about a half mile from the factory entrance. Walking to work was time consuming, and there was no direct route. The new bicycle railroad was a perfect solution. (Donated by a private collector.)

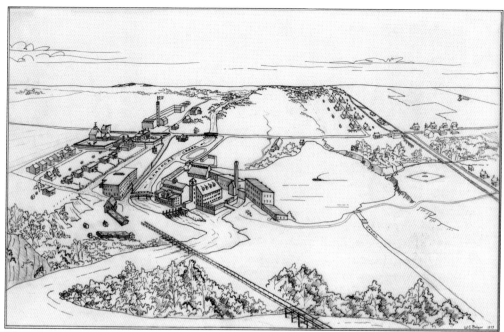

This illustration of Smithville drawn by William C. Bolger shows the upper village, the H.B. Smith Machine Company Factory, the mansion, the farm complex, the railroad tracks, and the lower village with the baseball field. At lower left is where the Mount Holly and Smithville Bicycle Railroad would have approached the village. (Courtesy of the Burlington County Board of Chosen Freeholders/Division of Parks.)

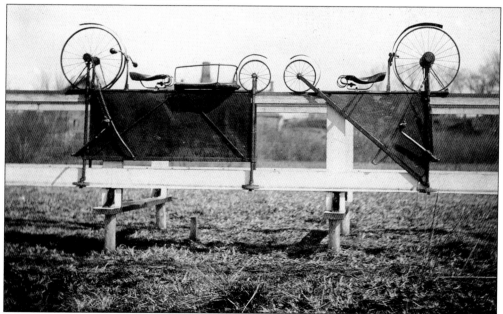

A tandem (left) and a single rail fence vehicle sit on the track of the Mount Holly and Smithville Bicycle Railroad. The framing was made of weldless steel tubing. The front wheel is 20 inches in diameter, and the rear wheel is 10 inches. Both are made of hickory and surrounded by grooved steel rims. (Donated by a private collector.)

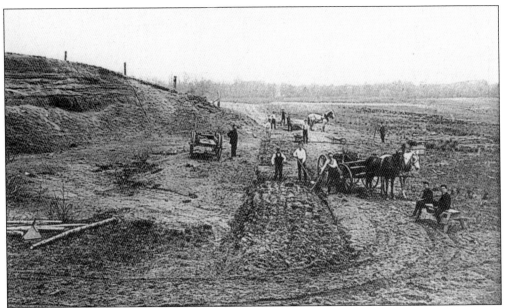

Workers prepare the bed of the 1.8-mile Mount Holly and Smithville Bicycle Railroad in 1892 while inventor Arthur Hotchkiss (center left) supervises. A single rail fence was completed for the opening of the railway in September 1892. Numerous promises were made by Hotchkiss to finish the dual railway, but it was never completed. (Donated by Barbara and Everett Turner, courtesy of the Burlington County Board of Chosen Freeholders/Division of Parks.)

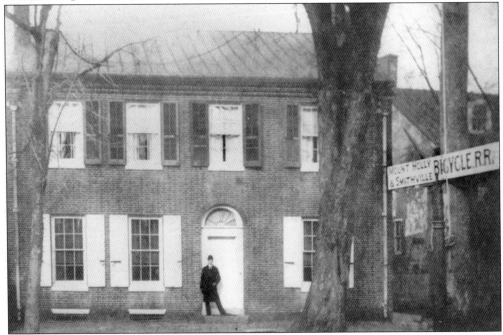

A sign advertising the Mount Holly and Smithville Bicycle Railroad is mounted on a pole at the intersection of Pine and Mill Streets in Mount Holly. The location of the sign is just down the street from the terminus of the railway behind the Relief Fire Company. (Donated by Barbara and Everett Turner, courtesy of the Burlington County Board of Chosen Freeholders/Division of Parks.)

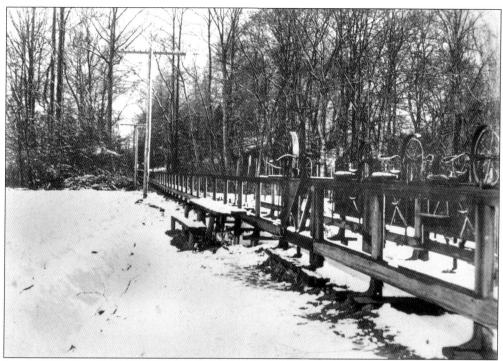

Mount Holly and Smithville Bicycle Railroad vehicles are lined up at the Smithville terminus in the snow. Ridership in the winter months was slow, and H.B. Smith Machine Company workers were the only riders. The wooden steps were used to mount the vehicles. The rail line terminus in Smithville only had one track, as can be seen as the line goes off in the distance. (Courtesy of Kim and Wayne Batten.)

This piece of a support post with iron castings once used as part of the Mount Holly and Smithville Bicycle Railroad track was placed in front of a sign explaining the railroad at the Smithville Park in Eastampton. This post and a few bicycle railroad vehicles are all that remain from the 1.8-mile railway built more than 125 years ago. (Photograph by the author.)

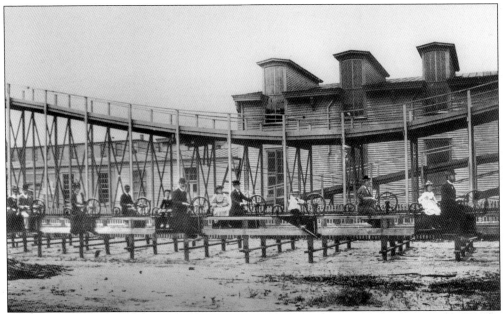

Arthur Hotchkiss took his bicycle railroad to the 1893 World's Columbian Exposition in Chicago to promote the idea. He constructed a small demonstration track at the world's fair with bicycles built by the H.B. Smith Machine Company. Unfortunately, the only bidders for his bicycle railroad were amusement ride operators. Alfred and Edward Moore built one in Atlantic City, New Jersey, in 1894. (Courtesy of the Atlantic County Historical Society.)

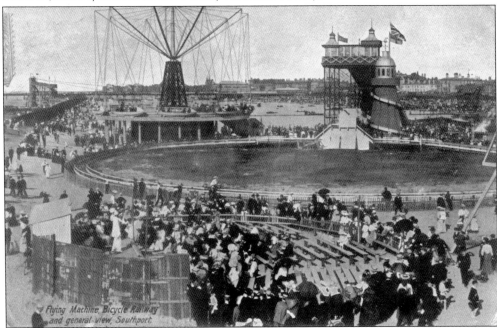

Englishman William George Bean bought the rights to the Hotchkiss Bicycle Railroad after visiting the 1893 fair. He designed amusement rides with a 250-foot dual oval track using the Hotchkiss-designed bicycle railroad vehicles. They were among the first rides included in his amusement parks. (Author's collection.)

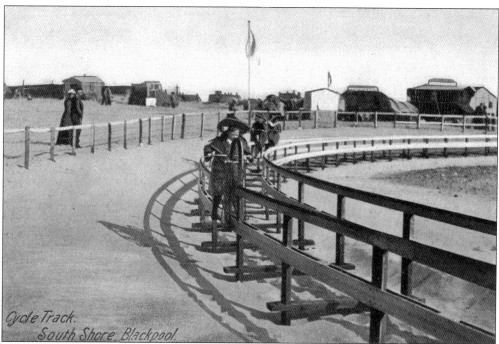

From 1894 through 1898, Bean built or licensed Hotchkiss Bicycle Railroad amusement rides on the Isle of Man and in Cleethorpes, Southport, Great Yarmouth, and Blackpool, England. The rides were composed of two 250-foot ovals where the single and tandem vehicles could be ridden. The bicycles were built at the H.B. Smith Machine Company and shipped to England. Shown are the amusement rides located on the beach in Blackpool. The bicycle railroad amusement rides in England lasted longer than the Mount Holly and Smithville Bicycle Railroad. (Above, author's collection; below, courtesy of the Blackpool Pleasure Beach Resort, Blackpool, England.)

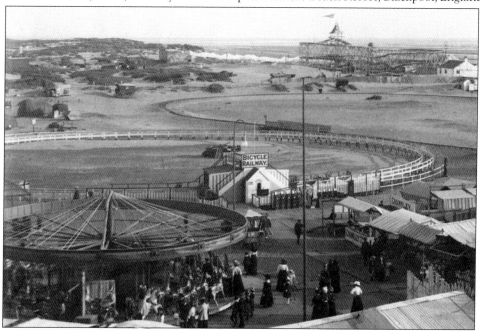

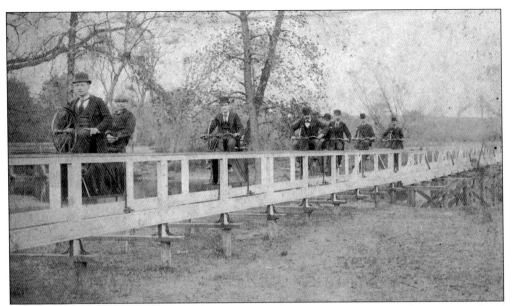

Workers use tandem and single-rider vehicles on the Mount Holly and Smithville Bicycle Railroad to get to their jobs at Smithville. When the H.B. Smith Machine Company was at full employment, more than half the workers at the factory lived in Mount Holly. The bicycle railroad provided an inexpensive means for them to get to work. (Courtesy of the Burlington County Board of Chosen Freeholders/Division of Parks.)

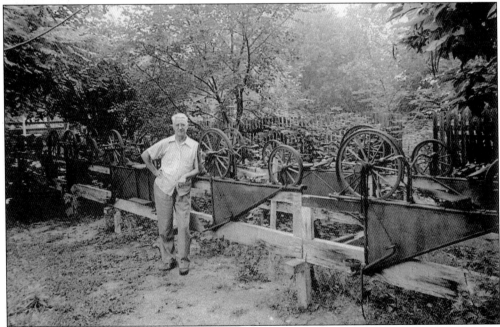

In 1937, Joseph Wolfram, a Mount Holly postmaster, discovered numerous discarded bicycle railroad vehicles in a neighbor's barn. He built a makeshift rail line and mounted the vehicles on a fence-like structure in his yard. His discovery brought attention and renewed interest to the forgotten Mount Holly and Smithville Bicycle Railroad. (Donated by Barbara and Everett Turner; courtesy of the Burlington County Board of Chosen Freeholders/Division of Parks.)

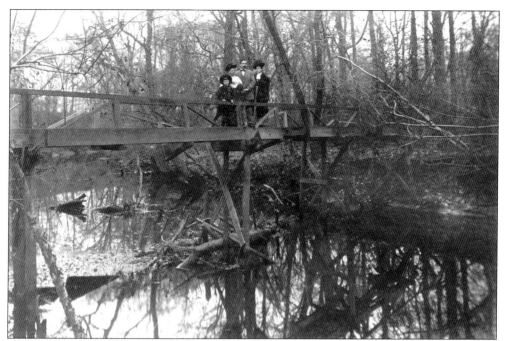

A family stands on a dilapidated and overgrown section of the Mount Holly and Smithville Bicycle Railroad after it was abandoned in 1898. Poor maintenance of the railway, the inability to complete the dual track, and the advancement of other means of transportation doomed the novel railway. (Courtesy of the Burlington County Board of Chosen Freeholders/Division of Parks.)

Today, a mural of the bicycle railroad is painted on the side of an auto parts store near the intersection of Madison and Washington Streets in Mount Holly. At the first annual board meeting of the Mount Holly and Smithville Railroad Company in July 1893, it was reported that 20,000 passengers had ridden on the line since it opened the previous September. Unfortunately, the world's first bicycle railroad lasted only six years. (Author's collection.)

Discover Thousands of Local History Books Featuring Millions of Vintage Images

Arcadia Publishing, the leading local history publisher in the United States, is committed to making history accessible and meaningful through publishing books that celebrate and preserve the heritage of America's people and places.

Find more books like this at
www.arcadiapublishing.com

Search for your hometown history, your old stomping grounds, and even your favorite sports team.

Consistent with our mission to preserve history on a local level, this book was printed in South Carolina on American-made paper and manufactured entirely in the United States. Products carrying the accredited Forest Stewardship Council (FSC) label printed on 100 percent FSC-certified paper.